SOUTHERN STEAM DAYS REMEMBERED

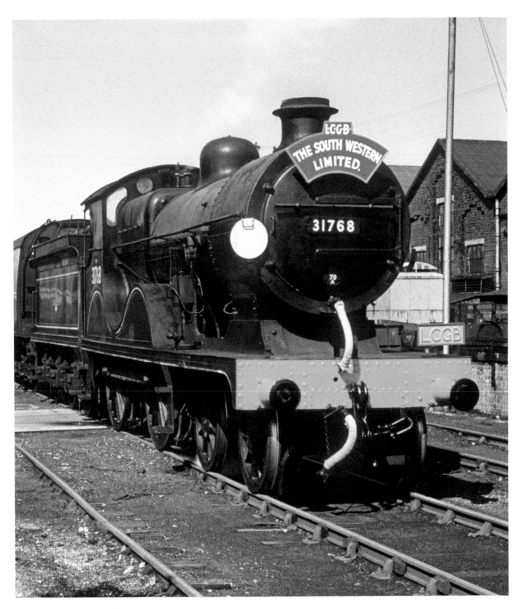

L Class 4-4-0 31768 at Eastleigh Works. See p. 94.

SOUTHERN STEAM DAYS REMEMBERED

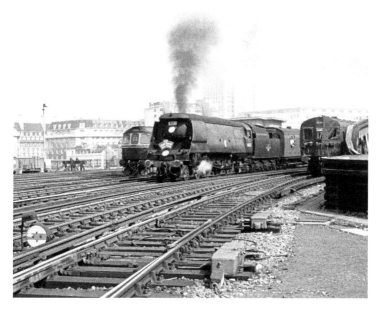

The disastrous LCGB Green Arrow Rail Tour on 3 July 1966 was forced to find West Country 34002 Salisbury for the first leg out of Waterloo as Gresley V2 60919 had been failed on the journey down from Aberdeen. (Strathwood Library Collection)

Kevin Derrick

AMBERLEY

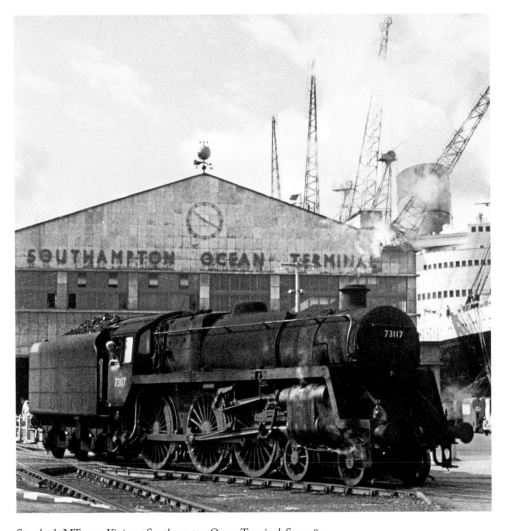

Standard 5MT 73117 *Vivien* at Southampton Ocean Terminal. See p. 82.

This edition first published 2017

Amberley Publishing
The Hill, Stroud
Gloucestershire, GL5 4EP

www.amberley-books.com

Copyright © Kevin Derrick, 2017

The right of Kevin Derrick to be identified as
the Author of this work has been asserted in
accordance with the Copyrights, Designs and
Patents Act 1988.

ISBN 978 1 4456 6977 9 (print)
ISBN 978 1 4456 6978 6 (ebook)

British Library Cataloguing in Publication Data.
A catalogue record for this book is available from
the British Library.

Origination by Amberley Publishing.
Printed in the UK.

Contents

Preface

I have wanted to compile a large format album to share some of my favourite colour shots from the Southern's steam days for some time. In compiling this collection a number of views have had to be omitted for fear of accusations of bias towards certain classes or locations. Therefore I am sure that if this volume is successful we will come back and revisit the region once more for another selection.

This has also given me the chance to provide a platform to share some footplate experiences from a long-term friend, Roger Carrell, whose acquaintance I had the pleasure of making almost quarter of a century ago in Perth in Western Australia. Through the wonders of email we remain in touch to this day within a close group of friends across the globe who share a passion for Southern steam.

We will all have our favourites from the past, I hope you will enjoy this compilation and we must also thank the foresight of the photographers and the kindness of those who have allowed their work to be seen and appreciated by a wider audience.

Kevin Derrick
Boat of Garten 2009

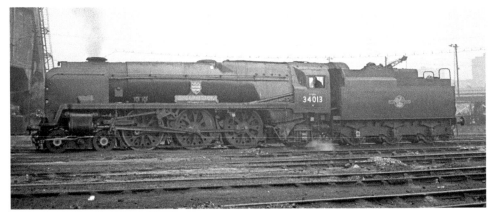

Our first engine for the day awaits: 34013 *Okehampton* in the early morning light outside the sheds at Nine Elms. (Win Wall/Strathwood Library Collection)

Introduction — One Day in a Lifetime

A distant clock chimes one-thirty in the morning as I make my way to work along a wet street in late November. I'm cold and weary. Grub bag, surge jacket, reefer coat and raincoat hang heavy upon my shoulders. My eyes are sore from interrupted sleep, care of the neighbour's mut, and "Damn, it's started drizzling again!"

The street lamps reflecting upon the wet road dazzle my eyes and cause me to withdraw to a cosy sanctum within myself. "Hell, what a miserable place. If I win the pools tomorrow, they can shove this lot up their cylinder cock," while I imagine a palm tree paradise with bouncing Wahines.

I'm returned from heaven to hell by the approach of a lone bobby, poncho draped from neck to spokes. We search each other's eyes like two white men meeting in darkest Africa. A nod from him, a "Mornin'" from me. "I wonder what he's thinkin' about, Barbados, no doubt!"

I turn the corner from Wandsworth Road into Brooklands Street and as I gaze through the drizzle, the means of my livelihood gradually looms before me. I pause at the gate to pull faces at the timekeeper. "Anuvva wishy-washy night, Tom!" I bellow. "Who for boyyo, you or me (chuckle)?" He responds. Lovely Welsh courtesy!

Cautiously I plod my way through muddy, oil-impregnated coal dust across the reception and departure roads. I glance toward the 'table' on my left, not much on tonight, Charlie (the 'tableman') will be gettin' a few 'zeds'. I forget where I'm going and trip on a lump of coal and react just in time to save myself falling.

"Who in their right mind, but me, would be up at this hour, out in this weather, and which idiot left that ruddy coal there?" I feel my frustration bringing warmth and life back into my body as I enter that dim, smoky cavern of a shed.

I spot one, of a rare few, of the Southern's enginemen/enthusiasts come bouncing out of the 'lobby'. "Mornin', lad!" "Mornin', Bert!" I stop to watch him slowly vanish into the smoke as if skipping his way to his loco. "Dunno how he does it, he must have a secret I haven't learnt yet!"

Opening the foreman's office door and I slam my eyes shut to protect them from the brilliance. Through my slitted eyelids I spot Sid the foreman; thin frame, blue dustcoat and his neck hanging forward from rounded shoulders, just like a vulture! "What's our mount for the free-a-clock mail, Sid?" "Firty four – firteen on road 9," he replies.

I return to the smoke-filled dimness and begin to make my way across the boards (straddling the pits) towards road 9. "One, two, three ... eight, nine." I turn left through an avenue of cylinders and spokes and there she is.

Onto the footplate, bag into locker, strike a match and check the water level; half a glass and twenty pound of steam. I open the firehole doors ('butterflies'), and a faint glow tells me at least we have a spark to make a fire from!

Now for the worst bit, tools; there should be three fire-irons but there's only one, no shovel, no pick, no tail lamps, only one oil bottle, no kero lamp, but amazing, we have a kero bottle... blast, empty! Must get some lighting, wonder if there's enough steam to start the 'gennie'? I push the steam supply lever towards the backplate then

hop down the driver's (left) side, remove the pin, open the cover and (using the pin upon the armature) flick the gennie into life ... mmmMMM! Ah good, now for some tools.

Laziness had reduced the once civilised reputation of this depot and instead of tolerating the long walk to 'stores', we preferred to steal from other engines! Another Pacific idled adjacent to ours but she only surrendered one fire iron, one pick, a kero lamp, but (in sympathy) all the tail lamps I required. Four more locos were raided until I had my quota. Now to 'stores' for oil, kero and rags...sheer lunacy!

On return to my loco and a ghostly shadow on the footplate awaits me in the form of my driver for tonight, Fred Prickett. "Morning, Fred, what's on tonight, mate?" I ask. "Sid says this one's just come back from brick arch repairs, so you'd better keep an eye on it. Oh, and there's a 'thirty' on at Raynes Park for bridge repairs over the Epsom line." Fred grabs his rags, two oil bottles and a feeder. "When we've got a bit more steam to move her, fancy the thrill of an inside big end?" asks Fred. "S'pose so," I mutter.

As Fred vanishes to do his oiling, I check the coal situation to make up a fire; blower on full (not much steam, so not much damaging draught) and a shovelful of smalls onto that glow. I do my first and vital checks: ash hoppers clean, dampers full open and smokebox door shut nice and tight; a bit of ash on the front will need cleaning off later. While I'm up on the framing, I check the sandboxes and, amazingly for a Bulleid Pacific, they're near full. Maybe she was previously being prepared when the 'arch' was noticed.

Back to the cab, spread those flames and apply two shovelfuls of coal. Between firing rounds, the lamps are checked, cleaned, filled and lit. Taking one red lamp, I place it to the right of the front buffer beam (as viewed from the cab), and sweep off the ash. Now around to the rear of the tender to place boards and switch in my 'Salisbury' lights (one at the top, one at the bottom), check my brake and heating hoses, bracket the coupling and then up the ladder to check water level and push some coal forward; discarding the larger lumps for later. When satisfied, I clamber out of the bunker, over the front of the tender and drop down onto the footplate in three giant steps, with a style befitting a swashbuckler!

I open the 'butterflies'; spread the flames across the entire grate and spray some more 'smalls' on. Now she'll start making steam. The next half hour is a test of patience – periodically feeding in 'smalls' and, as pressure-raising takes its own time, reducing the blower to just maintain a minimum of draught.

Between establishing a good bed of red coals ready for the larger lumps, time is taken to have a good clean-around: spectacles, side windows, seats, boiler backplate and a bit of the floor.

After twenty minutes, steam pressure's up to sixty pounds and a call from Fred sees me take off the handbrake, open the small ejector, select reverse and tug on the regulator (having sounded a watery whistle!). "Roar" (from the cylinder cocks), "Bang" (from the motion) and she moves, then, "Whoa!" She's positioned for access to the inside big end so I screw down the handbrake hard, harder, HARDER(!!!), then jump down to receive the kero lamp and feeder. "Good to see you young uns taking an interest in the job!" jibes Fred.

I walk to the front, jump down into the pit and crouching, walk back beneath the bogie and first driver. Now up into her guts; first step, second, third and fourth, with a feeling that I'm entering a forbidden tomb!

Both feet positioned now and I can lean back against the frame stretcher to catch my breath. As my lungs expand, my ribs press hard against the axle crank and my back hard against a stretcher. "Yuuuk!" Cold, wet oil soaks through my overalls jacket and tee-shirt onto the skin of my back. I exhale sharply and lunge for the front cork "Gotcha!" The smoke from the kero lamp, sitting on the crank, fills my nostrils and smarts my eyes.

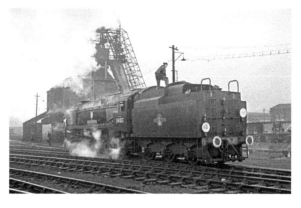

34013 at Nine Elms. (Win Wall/Strathwood Library Collection)

"Two done, one to go; there." I take a brief moment to look around at masses of steel, dozens of oil lines and above me, the radiating warmth from an efficient boiler.

Time to climb down and re-enter civilisation. My back starts shivering and I make haste to the cosiness of the cab. Fred's been progressing the fire and hopefully, checking the rear for other engines!

I take over the shovel and with the pressure gauge passing one hundred, Fred calls out, "All set, mate?" "Yep," I reply. I struggle to release the tight handbrake, the cylinder cocks roar and we glide slowly out of the shed. I start one injector, then hop down to call "Whoa" for the water column, swing her over, climb the tender and shove in the bag. Up here it's cold and I'm shivering again; at least it's stopped raining!

We're filling the tender slowly to allow time for the injector to fill the boiler to the top nut of the gauge glass, which Fred watches from the cosiness of the cab! Bang, the injector's shut off and a few minutes later, there's a gurgle and roar as water cascades over the rear of the tender.

I rejoin the cab and continue with the fire as we cautiously reverse toward the 'table'. We whistle for access, which brings Charlie limping from his cosy armchair. Bang-bang-bang, as we roll onto the table.

A 'whoa' from Charlie and a whirring sound turns us toward the departure road and the 'Cenotaph'. I'm busy emptying the tender of its black contents to fill up the back corners, then under the door until it's totally blocked by coal.

We're passing under the chutes; "Whoa" from the coal attendant. I quickly slam the coal door shut, then, drop the tray flap just in time as five tons of coal slams into our tender and we're engulfed in a cloud of dust. "Bit more, bit more, THAT'LL DO," shouts Fred. Now for some fireworks to liven up the fire; Fred opens the sanders (good job I checked those!) and plays with the regulator; chuffety-chuffety-chuffety, as we do fifty miles per hour in the same spot! "Come on, girl, haven't got all night!" She takes to the beach deposited on the rails and we edge forward, up the steep incline toward the yard foreman's hut. We pause here for me to trim coal on top of the tender while Fred nips over, tea can in hand, for boiling water. Three minutes later, Fred and I are back on board, so we meander up to the exit starter while I sweep and hose the floor and tender front. The coal's given a shower too, in readiness for a tender-first run to Waterloo to pick up our train.

Meanwhile, time for a well-earned cuppa – Haaaa!

This was a most rewarding moment for any engineman: the fire made up to the top of the firehole door, the tender coaled and watered, the boiler backplate polished with oil, the floor washed clean; time to contemplate future events while enjoying a fresh brew of tea and an "Old Holborn", accompanied by the hum of the generator and the cosy warmth of a living machine.

An incoming M7 0-4-4T sneaks past us and heads for the reception pit beyond the 'Cenotaph', having come on shed from its last empty stock working from Waterloo to Clapham carriage sidings. As it vanishes into the darkness, we get the 'dummy' (ground disc signal) and Fred opens the regulator and releases the vacuum brake. There's a loud roar from the cylinder cocks which echoes back from a street of terraced houses and we edge forward up the incline toward the loco spur on the south side of the main running lines.

We arrive at the spur, coming to a stand just beyond the crossovers and await the 'off' of another 'dummy' to release us onto the running lines. As we stand there, I wander over to Fred's side of the cab to study the dismal empty street below and the austere terrace houses fronting on to it. At this hour all is deserted and quiet. The safety valves start to feather, so I put an injector on to keep her quiet; 'Bang-Gurgle'; I don't know what's noisier – the safety valves lifting or putting the injector on! The coal sprays are turned on again for tender-first running. I hear a clatter and glance rearward. "We've got the dummy, Fred!" I call.

As silent as a ghost, we glide out of the siding and clatter over the crossover onto the down local, thence, up local line! We continue up the incline and onto the arches, through Vauxhall then cautiously over the maze of tracks which guides us onto our train at the terminus. When the buffers come together, I hop down to couple-up, then turn out my 'Salisbury' lights on the tender, grab two 'boards' from the cab and place them at the front of the loco (one at the top, one at the bottom), switch on their corresponding electric lights and remove my red tail lamp.

Back on the footplate, I check my fob watch; 0250 hrs; time to warm her up! The dart is selected from a tender fire-iron tunnel and pushed into the heap of coal in the firehole door. The blower is put on to liven up the fire and help dissipate the plume of black smoke created as I push the dart deeper into the fire and lever it upwards. The safety valves are 'feathering' again so I turn on the train steam heating and one injector to keep her quiet.

The guard appears and gives us the train particulars. "Thirteen bogies on, 393 tons tare, 557 tons gross." He takes Fred's name, has a quick chat about last summer's tomatoes(?), then vanishes back amidst the crowd of toiling porters unloading their trolleys full of parcels.

It's 0259 hrs; the fire's just right, the water is bobbing in the top nut of the gauge glass and one safety valve is blowing off fiercely. There's a green aspect showing with 'MT' ('Main Through') as we think we hear the guard's whistle echo within the station canopy. We glance back to see a green light being waved. "Right-away," Fred and I call simultaneously.

She's in full forward gear, the vacuum brake is off, the steam brake is released and the regulator opened. 'Thump', as the steam hits the chests. 'Roar', from the open cylinder cocks, which are then closed. 'Chuffety-chuffety-chuffety', as a Bulleid Pacific gets to grips with her task. Fred opens the sanders and the wheel slip stops and we're off!

To an engineman, more than to an enthusiastic passenger, this was a moment to wonder; will she steam OK, will we keep to time, how fast will she go, what awaits us

along the line? The safety valves re-seat so I close the 'butterflies' to bring the fire to white-heat.

We negotiate the maze of turnouts and crossings as Fred plays with the regulator to prevent any more wheel slip. Once through the maze and over the top, the banker's pulled away and we're on our own. Full regulator now and 50% cut-off as we begin accelerating within the 55 mph ceiling towards Clapham. We're up to 30 mph as we pound around the S-bend at Vauxhall, then drop down the incline past Nine Elms goods yard. We roar past a deserted Queens Road (Battersea) station, white-hot cinders shooting vertically skywards as we get our heavy and tightly timed train under way.

On the eastern approaches to Clapham, our speed is up to 50 mph and Fred swings the blower on and slams the regulator shut to apply a little braking for the 40-mph limit curves through the station. The safety valves 'feather', then lift, so I put the injector on, open the 'butterflies' and swing ten shovelfuls into her. I'm overjoyed; one of the sayings among Nine Elms men was, "If she's not blowing off by Clapham, you're in for a rough trip!" Halfway around the curve, Fred selects 40% cut-off and opens her up again. I shut the 'butterflies' and turn off the blower for the steep climb to Earlsfield. The injector will stay on now, for the rest of the journey, with occasional fine adjustments to the feedwater valve. At the start of the climb, we glance over at the Eastern and Central Section lines curving away to the left where a Standard Class 4MT 2-6-4T hurries 'light engine', presumably, towards Stewarts Lane Depot.

We roar over the top at Earlsfield, having just maintained 40 mph on the way up and now some acceleration is expected before the final climb through Wimbledon. I check the injector to ensure that it's operating correctly, then open the 'butterflies' for another ten shovelfuls, paying particular attention to filling up the back corners, then under the door. (The vibration of these locos with their square, sloping fireboxes tended to gradually work the fire forward, so it was a comparatively easy task keeping the rear of the fire fed.)

Every steam locomotive I'd worked was different. Each, even within the same class, possessed its own personality. The paramount advice among all enginemen was "Always keep ahead of her!" Thus, upon taking over a new 'mount', a little time was required to discover its habits before the 'beast' became predictable and could be tamed. (Something akin to mounting a snorting bull, actually!)

It shouldn't take much imagination therefore, to realise that when a steam locomotive travelling at high speed, is being pushed nearer to its design limitations, the gap between predictability and consequences becomes very fine indeed and in some cases vanishes altogether!

We're up to 50 mph as we jerk over the double junction at the east end of Wimbledon station. (The up line was very rough and a constant cause for complaint from enginemen.) After Wimbledon, there's a further climb until the line levels out at Raynes Park and onto Berrylands, but as we're passing the South Yard all that reprieve is kissed goodbye as Fred shuts off and provides a good brake application for the Epsom line bridgework just west of Raynes Park. A Q1 ('Charlie') 0-6-0 is seen entering the yard with a rake of empty milk tanks from Morden Co-op Dairies.

We coast through Raynes Park station; ahead of us is a blaze of hurricane lamps so Fred sounds the whistle. As we rumble over the bridge at 30 mph, it's comforting to see that other human beings are conscious at this hour as we nod to each other.

The speed restriction 'clearance' board is placed far beyond the work location to allow for the passage of long goods trains and it seems to take an eternity before we reach it. A hundred yards from the board, Fred mutters, "That'll do," and opens her up again. The 30 mph check has, so far, cost us two and a half minutes in relation to our schedule and we'll have to push her hard to make up the lost time. At 50% cut-off and full regulator, we're up to 45 mph at New Malden and 50 mph by Berrylands. Fred eases back to 40% as we drop down toward Surbiton.

It's times like this that one wishes for the extra capacity of a Merchant Navy, but this Light Pacific seems to be in good fettle; the needle has barely moved off the mark as we pound through Surbiton. We're touching 60 mph by Hampton Court Junction and I begin (at last) to experience the exhilaration from a mile-a-minute running.

Fred still hasn't altered the cut-off by Esher, as we were four and a half down at Surbiton and *Okehampton* is hungrier for coal than I'd anticipated. I begin to increase firing frequency from ten shovelfuls every three minutes to ten every two and the fire begins to take on a more respectable shape within the white brilliance. There are many dreads at a time like this, such as injectors failing, the brick arch caving-in or a large lump of coal blocking the tender chute. So far, so good, however!

On the level at Byfleet, we're up to 75 mph and Fred reduces the cut-off to 35% to maintain this speed on the gradual climb through Woking and onto Milepost 31. Time to clean around, roll a smoke and have a sip of stewed tea.

We're up to 77 mph when Fred stands up, has a delightful stretch, then grabs the 'cable' and sounds the whistle at the approaches to Woking, while I sympathise with the occupants of nearby houses! "Woosh-woosh-woosh" echo the sundries on the platform. "Roar-roar-roar", echo the station buildings and, like thread passing through the eye of a needle, we're through.

Another ten shovelfuls are administered as we thunder over Woking Junction; carrying the lines to Guildford, then with the cut-off advanced to 40%, we commence the steeper climb to Brookwood. Again we're entertained by a fireworks display from the chimney. I glance back to watch the white glowing cinders cascading from the roofs of the ninth, tenth and eleventh vehicles like starburst. Fascinating!

There's Brookwood and we're through at 80 mph, having actually accelerated up the incline! Now for a steadier climb to Pirbright Junction. Fred gestures to me and I plant my ear to his nose. "Three and a half down by Woking," he screams, in an effort to overcome the roaring decibels surrounding us.

We pound around the curve past Milepost 31 and drop down through Deepcut. Speed has steadily risen to 85 mph as we plunge into the tunnel (carrying the Basingstoke Canal over the line) before Sturt Lane Junction. The noise in here is almost unbearable. White hot cinders are now ricocheting down on OUR roof and forming glowing curtains, seemingly draped from the cab windows. Pungent sulphur fumes burn my nostrils and throat, so I hold my breath until we're out into fresh air again.

Sturt Lane Junction flashes by and I just catch a glimpse of a Guildford to Reading transfer goods meandering beneath us, with its loco firehole glowing to reveal the silhouette of a U Class 2-6-0. I set up the 'butterflies' for another round but, after two shovelfuls, I'm greeted with a thud from a large-sized lump! I grab the pick and take to it. There's an easy way to break up coal; by tapping it along its side grain. But this 'beggar' is only revealing its end grain through the tray chute! I chip away at it, causing pieces to fly in all directions. Fred glances over with an expression of one about to experience the effects of several de-pinned hand grenades!

I chip and it falls half an inch; more chipping and another half inch. I'd love to open the tender door and see what I'm dealing with, but we don't need a cabful of coal just now! In the back of my mind I know that this delay is deteriorating the shape of my lovely fire. I keep at it as we snake around the curve through Farnborough and onto the 'Racetrack' towards Basingstoke. Our speed is up to 85 mph now and Fred eases the cut-off back to 30% ... thank goodness!

It's bad enough having to gradually chip away at a large lump of coal on a stationary engine, but on a 'bucking-bronco' doing eighty-plus, it's a right pain in the proverbials: Feet apart, placed diagonally to the direction of the loco, both hands gripping the pick with the knowledge that a sudden lurch will throw you to the floor, if not against something sharp and solid. I glance occasionally at my gauge glasses and pressure gauge; they're holding up okay, but a check of my deteriorating fire brings frustration, causing me to return to the offending lump like an angered gladiator!

I'm pretty well exhausted as I lever the last foot through the tray hatch. The thing must have been four feet long and two feet wide! Now to re-establish a respectable shape to my poor fire. I open the 'butterflies'; the back corners are empty and the cold air passing through them is beginning to affect steam pressure. I select the pricker from the tender and push the white-hot mound, in the centre, towards both sides and those back corners. Now for some continuous shovel-work, placing each charge onto a different part of the fire, but concentrating on those vulnerable back corners. Definitely a case of 'little and often'.

With the fire looking almost reasonable again, I shut the 'butterflies' and lunge for my window to enjoy a moment of rest and some cool air. My overalls jacket is wet while beads of sweat run down my face and smart my eyes. "My hands are shaky and my knees are weak, I can't seem to stand upon my own two feet..." That famous song by Elvis, appropriately, runs through my mind to the (double) rhythm of the loco's motion. The ground beneath my side rises to become the disused island platform of Hook; we'd passed Fleet and Winchfield without me noticing it!

The last charges of coal must be well alight by now as steam pressure has crept back to the mark. I put the icing on the cake by administering some more coal which brings the shape of the fire back to normal. Just as well, as we'll need it for the climb through Basingstoke up to Worting Junction. As we pass Old Basing village, I glance at the clock; steady on 85 mph with the regulator nearly touching the roof and the cut-off still at 30%. Good old Fred, realising my plight, had compromised his intention to be right-time by Basingstoke, to allow me some respite.

Thank goodness; we've got the 'distant', allowing us a clear run through! Our 'clatter' is echoed back from a rake of stock in the East End carriage sidings. As Fred sounds the whistle, I observe the Reading Line crossovers ahead and the thought enters my mind that, at such a speed, we may not negotiate them! Too late to brace myself, we're over them and leaning to the right hand curve through the station! Even with super-elevation, she lurches in protest accompanied by a roar of amplified, spirited applause from the station buildings. The roar subsides as we flash under the West end gantry and past the MPD, we're through!

Fred checks his fob watch, then advances the reverser to 35% for the last of the climb to Worting. She's fair chattering now, so I stagger over, gesture to his timepiece and position my ear for a response. "One and a quarter down," he yells. I throw in ten shovelfuls, test blow my gauge-glasses, roll one smoke, drop into my seat and take a mouthful of treacly tea – Yuuuk!

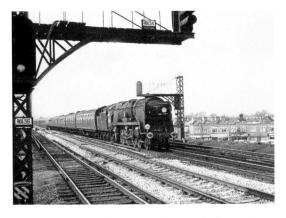

34013 at Raynes Park. (Strathwood Library Collection)

It's drizzling as we negotiate the last of the climb to Worting Junction. Just west of the Down Yard, she goes into a wild spin on the greasy rails and the 'clock' jumps to 120 mph (not quite *Mallard*'s record!). Fred reduces the cut-off to 2%, which proves an easier alternative than struggling with the regulator and she gradually decelerates back to track speed.

(I much preferred the direct, positive action of the screw reverser over the steam variety, fitted to the unmodified Bulleid Pacifics, which were generally so far out that I've often seen a loco accelerate a train with the reverser indicating 20% reverse cut-off!)

Another mile and we're approaching the junction. Fred shuts off and makes a light brake application for Battledown curves, about two miles ahead. We thread under the road bridge and there's the lonely signal box emitting a faint glow which highlights the drizzle around us. We plunge back into the mysterious darkness, our speed gradually reducing for the 60 mph curves. Within a few moments we experience super-elevation and she begins to lean heavily to the right. There's a roar as the flyover abutments echo our impatient progress. At 62 mph, Fred releases the brake and gives her half regulator to overcome the flange resistance on the curve. I haven't been subjected to the brilliance of the fire for some time and easily spot the green aspect of the 'distant' semaphore at the end of the curve. "We've got ROAR"... as the safety valves lift! I content myself with a thumbs-up signal which Fred takes as his cue to give her full regulator and 45% cut-off!

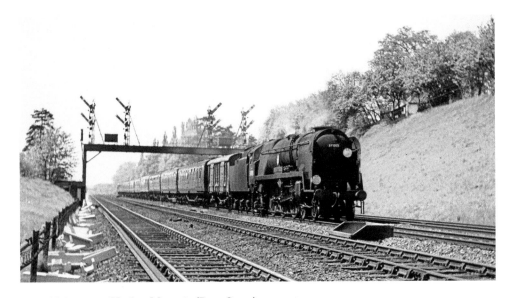

34013 *Okehampton* at Hook, 15 May 1965. (Peter Coton)

We begin to accelerate towards (a closed) Oakley, the 'safeties' reseat and, satisfied with my brief sojourn, I swing the 'butterflies' open and rebuild my fire for the switchback gradients to Grateley. Having cleaned around the cab floor a bit, I relax at my window to gain some more cool air. My attention turns to the fact that this is the 'Strong' country; a land of good beer, thatched cottages and quaint folk. I glance out across a black landscape and imagine a time of knights and kingdoms, of stagecoaches and highwaymen. I'm startled back to reality when Overton rushes by … (It's all relative!).

It's 0350 hrs and we've covered about 57 miles. At this bleak hour in the morning, one has to look at things three times before they register: gauge glasses, pressure gauge and, more importantly, the signals. It's getting to Fred as I observe him glancing sideways occasionally to escape the hypnotic effects of heat, rhythmic noise and signal aspects. "Is it really showing green or have I fallen asleep and dreaming it's green?"

I start bellowing a song, open the 'butterflies' and busy myself with another round. "How're we doin', Fred?" I shout, to keep him in this world! I'm feeling totally exhausted myself but, rather this pantomime than a tragic mistake! I imagine us both dropping off to sleep (no AWS this far west), roaring past a red signal, the carnage, and the headlines in tomorrow's papers: "Train crew give their lives to get mail through"!

We pass a solitary gas pilot lamp, which heralds our passing of Whitchurch station. I lean out to catch a glimpse of our motions. I never could understand how all that mass of flying steel could behave itself in the dark; I know it's there but I can't see it! I'm pleased when I notice Fred reach into his surge pocket and produce his well worn 'backie' tin. He fumbles for a "Rizla", then plunges his fingers into a generous mound of "Old Holborn". I 'crack' open the 'butterflies' to provide some more illumination. He lights up to add compliment to the normal aroma of the footplate. I watch his smoke expand into our environment only to contract again as it's drawn into the brilliant segment of the 'butterflies'. I feel inclined to join him and get my own adrenalin flowing.

Another solitary gas lamp witnesses our passing of Hurstbourne Priors: famous for its watercress. We commence the descent to Andover; at 86 mph, Fred reduces the cut-off back to 15%. She takes to the gentle curves without any objection and we're touching 94 mph at the straight approaches to the station. We had the 'distant' but, hell, we can't see the 'outer home'! Fred slams the regulator shut and is about to drop the 'handle' when we spot a green lamp being waved from the East End box. Fred sounds the whistle in acknowledgement and opens her up again. We roar through the station at 92 mph then Fred slips her back to 35% for the climb to Grateley.

I feed her plenty of 'porridge' for this, our last ascent before Salisbury. After this, I shut the 'butterflies and now that we're out in lonely countryside again, select the 'rocking bar' from its bracket on the boiler back plate, slip it into the right hand rocking socket and swing like mad on it to loosen clinker deposits which have formed on the firebars. I repeat the process for the left hand firebars. This operation, coupled with the heavy draught through the fire, creates holes here and there which I then fill with fresh coal.

After a quick brush-round, I sneak over to Fred's side and gently place my hand on his knee. He reels around in surprise, his face filled with horror! I stagger about in uncontrolled laughter. "The trouble with you young-pups," he bellows, "is you're too damn irresponsible; you don't know when to let up! In my day the drivers carried a piece of chalk in their pocket. They'd chalk a line on the cab floor and say, 'This is my

side and that's your-un; come too close and you gets a spanner up yer jacksey!" Humour waning, I bellow, "Well, will we or won't we?" "Should do," he responds, "with a clear run through Tunnel Junction; we were only forty three down at Andover!"

We disturb the tranquillity of Grateley as seven hundred tons of rolling steel thunders past at 85 mph. We commence the welcome descent to Salisbury and Fred keeps the cut-off at 35% for our grand finale. 86–87 … 99–100–101–102 … which is obviously enough for Fred as he winds her back to 10% and half regulator. Porton comes and goes before I realise it! I fill the 'box' right up to the top of the door and quickly shut the 'butterflies' to kill the glare and allow Fred to sight the 'distant'. It's green, so we stand a chance. I watch him intently. After all, we're doing the 'ton' and not far ahead are 'forty' curves! He is concentrating intently too, probably calculating speed and distance in relation to the signal. I'm waiting patiently as the 'distant' flashes by. Now patience gives way to anxiety! "Come on, Fred, that right-hand bend's getting closer; time to place the feet against the backhead and close the eyes!"

Just when I think it's all over for a youth in the middle of his prime, I'm jolted from my braced position by flames pouring from the 'butterflies'. I snatch the blower open as Fred drops the 'handle'. "He's done it!" The braking is terrific, we're down to 80 mph at the 'outer-home' but we've got to drop another forty before the 'home'! The home is passed at 50 mph and I brace myself again, stomach in mouth, as we hit the sharp curves and she wants to carry straight on to Southampton!

Fortunately, however, the wheels maintain contact with the railheads. Fred lifts the handle and we're down to forty at the minimum transition. We clatter over the junction and plunge into Fisherton Tunnel. I fill the bucket with hot injector water for a wash-up. We emerge from the other end of the tunnel and are greeted by a complete contrast of bright yard lamps and goods vehicles being marshalled – back to civilisation! We thread into the down local platform which is swarming with porters and trolleys and come to a gentle stand at the water column … fifteen seconds early! My relief swings the column over the tender and brandishing the platform shovel, climbs up the rear and shoves the pipe in, as I climb over the tender front to meet him in the bunker where we both feverishly push coal forward, while our drivers exchange pleasantries in the cab! After two minutes, the tender overflows. I yell to Fred who emerges from the cab carrying two bags and an empty tea can (yes, I drank it all!). He turns off the water and with the bunker nicely heaped where it's needed, I hop down the back and pull the crane clear while my relief hops down from the front. I collect my bag from Fred and realise he's left my surge jacket on my seat. I hop back onto the footplate to a grin from the Salisbury driver and a grateful smile from my relief for the generous condition of the fire. "Won't 'ave to touch 'er till Wilton, will yer," I shout in acknowledgement. I bid them farewell and jump down from the cosy warmth to dismal cold and spot Fred standing at the bottom of the platform ramp gazing at his ex-charge. As I study him, I notice a sparkle in his eye. Then, with an erect pride, he vanishes around the front, through a cloud of steam, to cross the tracks.

I take up his position, hoping to see what he saw and yes, there it is; towering before me is this live, warm, pulsating creature; two safeties blowing off fiercely. A workhorse eager to do what she does best; move heavy loads at high speed. With nobility and pride she stands, one of the last of her breed; like all the other Class 7s in the land, extremely capable yet overshadowed by the Class 8s. This is how the privileged enthusiast sees her, ignorant of the toil that brought her here. It's unbelievable to think that only two hours ago she was being nursed into life in a filthy cave in London!

I saunter around the front, across the tracks and up the ramp of the island platform, studying her all the while, like a craftsman admiring his handiwork. She looks good from this side; long, sleek and majestic, a boiler full of bulging power, her motions like bristling muscle. This, for her too, is just 'one day in a lifetime'.

I hear the guard's whistle; there's a thump from her steam chests, a roar from her cylinder cocks and the connecting rods strain against her crankpins. Gradually she moves, her load dragging like a millstone – impeding her progress. She pulls harder against her reluctant charges and in her impatience, slips fiercely on the wet rails. I wave to my relief and he reciprocates with a broad grin, then I watch her departure intently as she gradually vanishes into the darkness, while absorbing every movement and sound to remember forever. The GUVs and BGs roll by, each one at a faster pace than its predecessor until there's nothing but a solitary tail light receding into the dark, mysterious distance.

My self-awareness returns to shivers running down my spine; I'm cold, hungry and tired. The porters, their work finished, trundle their trolleys into the Parcels Office on the adjacent platform. I start walking eastward along the island platform to the cabin at the far end. We had a good trip down, considering what could have gone wrong; the brick arch could have fallen down (again!) giving us poor steaming, an injector could have failed from overheating or scale deposits, a gauge glass could have blown, the inside big-end could have overheated, releasing its garlic odour from strategically placed 'stink bombs'.

The cabin reached, I enter its warmth gratefully. The usual pungent smell of cheesy socks is enhanced by a whiff of freshly brewed tea and Fred's corned beef sandwiches. I wash up again and seat myself on the hard bench opposite Fred, who is absorbed in the latest news from yesterday's *Daily Mirror*! An up train draws in. The loco, which sounds like an unmodified Light Pacific, comes to a stand outside the cabin. I hear the blower hard on, the injector singing and the clatter from busy shovels pushing coal forward. "Who's relieving 'er, then?" I ask. "Alan Wilton and George Fursey; just talking to them before you walked in. They worked the 'one o' clock papers' down; 'ad a rough trip by all accounts; smokebox door not sealing properly." "Sounds like they're in for another one!" I respond.

I devour my cheese and onion sandwiches, washed down with a hearty brew of "Typhoo". Reaching into my bag, I find my diary and make the following entry: 27/11/63, 03.00hrs "Mail", 34013, "Okehampton", Dvr Prickett, good trip, max speed – 102 mph, 84 miles in 70 minutes; arrival 'right-time'.

My bones feel heavy after a meal and my eyes are sore so I settle down for a cosy nap. Next thing I know there's the sound of safety valves clanking into the platform. "That's us, mate, come on," calls Fred, from the door. I collect myself, gather my belongings and stagger out just as our loco comes to rest at the water column. "Here, give me your gear while you shove the bag in and push some coal forward," beckons Fred. I'm greeted by a filthy S15 4-6-0 on our Nine Elms bound goods. I stagger up the rear of the tender, tripping over everything in sight, and shove the pipe in; "Name, address, occupation?" I ask myself. A four hour trundle ahead; in here and in there, to avoid the faster traffic, what a contrast!

Tail End.

Roger Carrell 1989.
West Australia

Waterloo

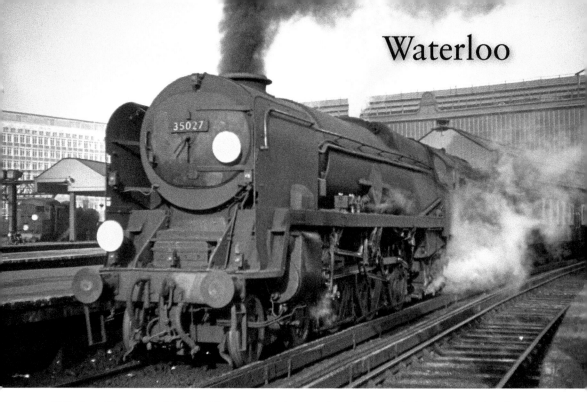

Filthy but still impressive, Merchant Navy 35027 *Port Line* gets the right away with the Bournemouth Belle on 23 January 1965 in the cold morning light. (Strathwood Library Collection)

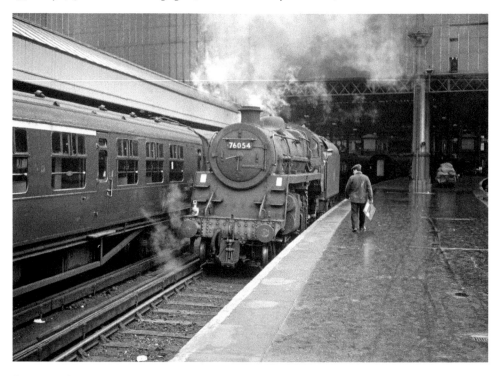

Setting carefully back onto its train in August 1964 is Standard 4MT 2-6-0 76054, for what will become the 12.42 to Basingstoke. (Late Norman Browne/Strathwood Library Collection)

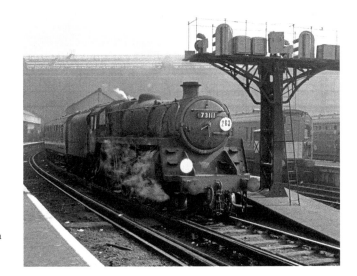

Countdown to departure is almost complete for Standard 5MT 4-6-0 73111 *King Uther* in 1964, alongside two Portsmouth line electric services. (Trans Pennine Publishing)

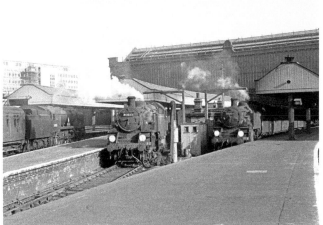

Ready to come to a gentle halt on arrival on 3 October 1964 is West Country 34014 *Budleigh Salterton*. Today's pilots are Standard 3MT 2-6-2Ts 82023 and 82027, resting between often frantic running across the very busy station throat to perform their duties. (Strathwood Library Collection)

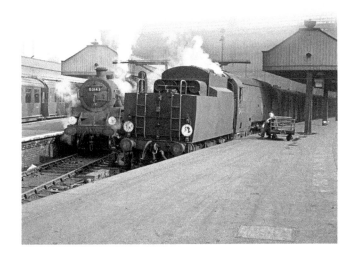

No such action at present for Standard 4MT 2-6-4T 80143 or Battle of Britain 34064 *Fighter Command*, which appears to be ready to work a train of vans back to Clapham Junction tender-first again in 1964. (Strathwood Library Collection)

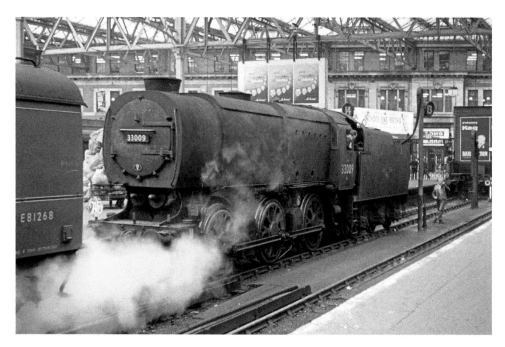

A chance for the crew to take their time topping up the tender of Q1 0-6-0 33009 on the buffer stops at Waterloo during 1964, having brought in empty stock tender-first for an out-going mail train. (Trans Pennine Publishing)

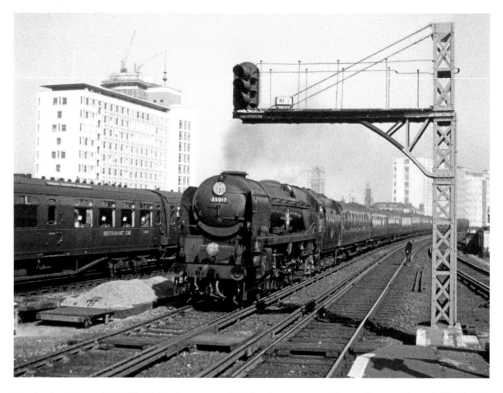

Getting into its capable stride with a down west of England express on 16 September 1961 through Vauxhall is Merchant Navy 35017 *Belgian Marine*. (Frank Hornby)

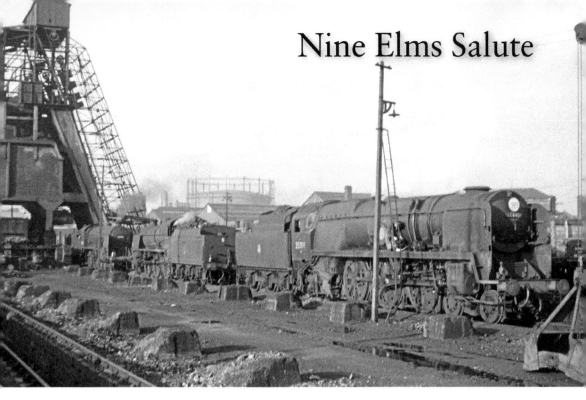

A dutiful fireman is on the footplate of Merchant Navy 35010 *Blue Star*, filling the sand boxes with a fresh charge of dry sand, on 25 February 1961; no doubt his driver will have call to use it at some point today. (Frank Hornby)

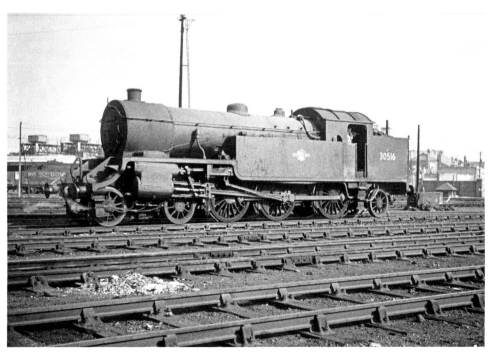

Often used at weekends for empty stock workings at Waterloo, away from their Feltham home base, would be one of the Urie designed H16 4-6-2Ts such as 30516, on shed on 4 October 1959. (Late William Potter/Stewart Blencowe Collection)

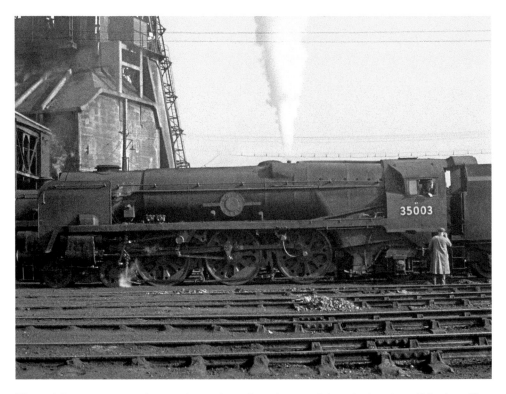

The yard foreman appears to be struggling to hear what is being said from the footplate of Merchant Navy 35003 *Royal Mail* as she blows from the safety valves in 1965. (Bob Treacher/Alton Model Centre)

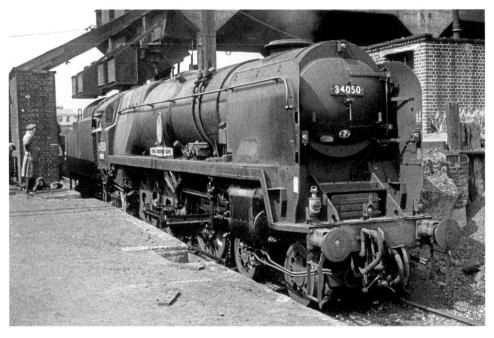

A short walk across to the "Cenotaph" on the same pleasant day in 1965 to see all is well on board Battle of Britain 34050 *Royal Observer Corps*. (Bob Treacher/Alton Model Centre)

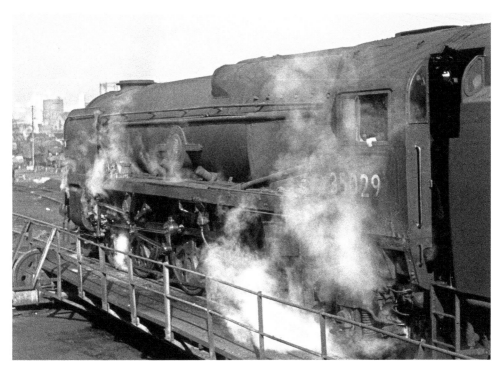

The bed of the turntable clanks loudly as the one hundred and forty nine tons of Merchant Navy 35029 *Ellerman Lines* makes its way forward again in the spring of 1964. (Bob Treacher/Alton Model Centre)

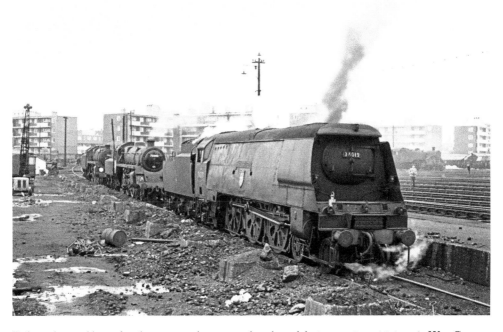

Perhaps the usual latter day clutter was to be seen on the ash road during a society visit in 1965. West Country 34019 *Bideford* is in company with a number of Standards that had seen off many of the old stalwarts from the Southern Railway's days. (Noel Marrison)

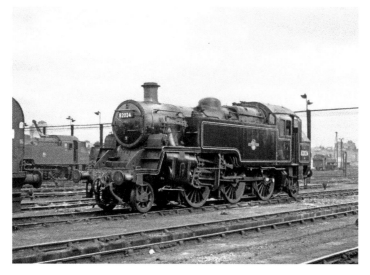

A very respectable Standard 2-6-2T 82024 had recently arrived at Nine Elms when photographed on 4 May 1963. The appearance of these in increased numbers would see of the off Drummond M7s and the Pannier Tanks very quickly now. (Frank Hornby)

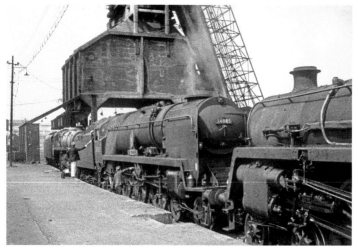

Busily preparing engines for the road in 1965 as Battle of Britain 34085 *501 Squadron* receives the caring attentions of loco crews. (Bob Treacher/ Alton Model Centre)

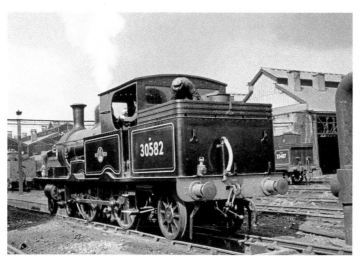

Booked for a special just after lunchtime on Sunday 19 March 1961, Adams Radial 2-4-2T 30582 is being prepared for its starring role at Nine Elms again after many years' absence from the capital. (Strathwood Library Collection)

Up the Junction

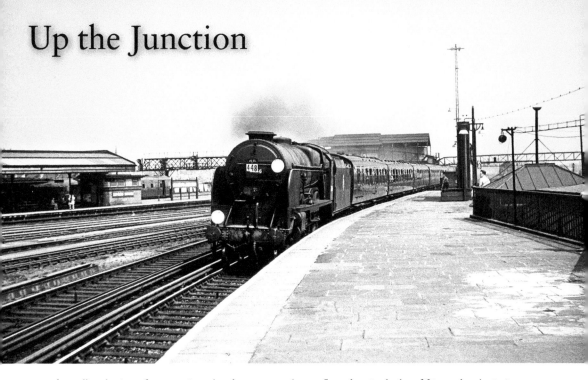

A small gathering of spotters is on hand, as was usual most Saturdays in the late fifties and early sixties, to record the action at Clapham Junction, such as Lord Nelson 30856 *Lord St. Vincent* with a down train. (Late Norman Browne/Strathwood Library Collection)

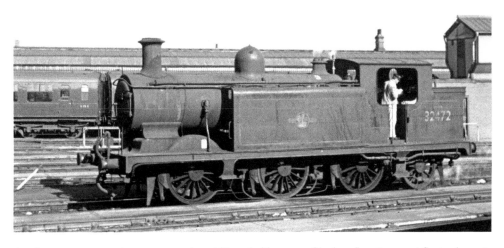

A quieter moment to take some tea on board E4 0-6-2T 32472 at Clapham Junction on 16 September 1961 during a lull in carriage shunting. (Frank Hornby)

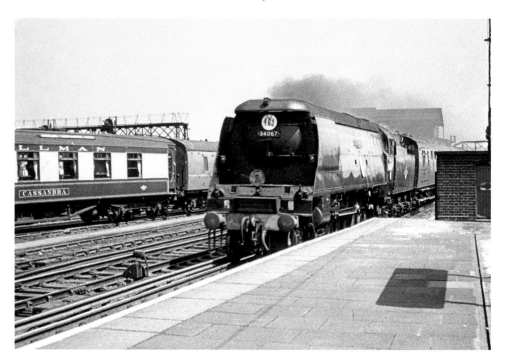

Stock from the Bournemouth Belle is being drawn out of the carriage sidings for duty in 1962 as Battle of Britain 34067 *Tangmere* shuffles its train smartly through. (Strathwood Library Collection)

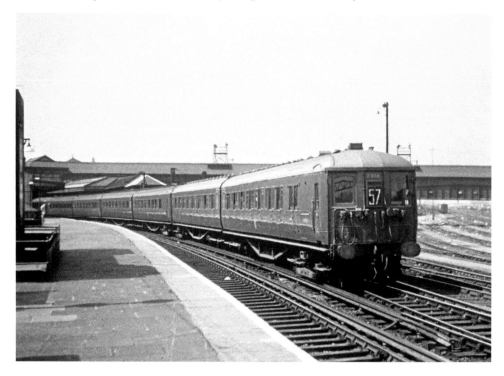

An up semi fast from Portsmouth sweeps round the curve and through the station on 2 July 1960 with 2-BIL 2064 at the head. (Frank Hornby)

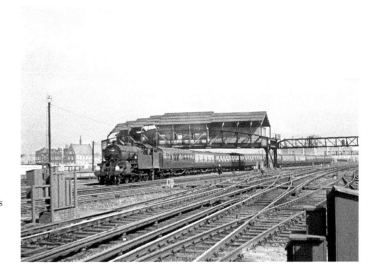

More empty carriage stock duties for another of Feltham's Urie H16 4-6-2Ts as 30519 brings a ten-coach rake into the yard off the Windsor lines on 31 March 1961. (Frank Hornby)

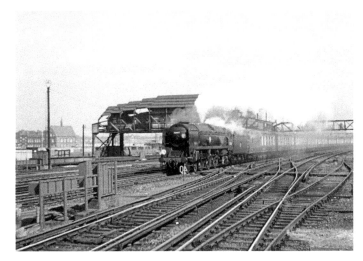

The fireman has Merchant Navy 35014 *Nederland Line* well up to the mark to accelerate along the main line with the down Bournemouth Belle a few minutes later on that same morning in March 1961. (Frank Hornby)

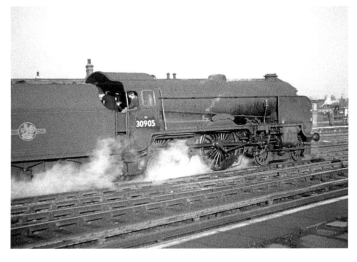

Fitted with the high sided tender from classmate 30932 *Blundells*, Schools Class 30905 *Tonbridge* is seen, again at Clapham Junction, three months later in June 1961. (Late Norman Browne/Strathwood Library Collection)

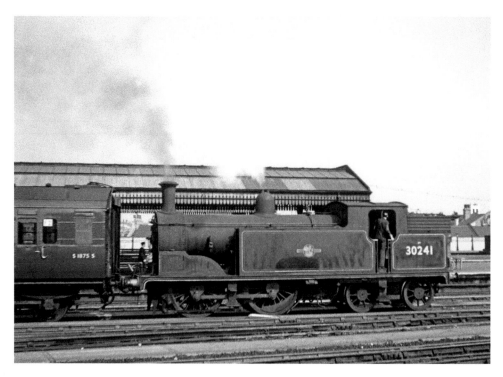

Drummond M7 0-4-4T 30241, a longer term Nine Elms resident, will take this rake of coaches to Waterloo to form another down train from the terminus on 8 August 1959. (Frank Hornby)

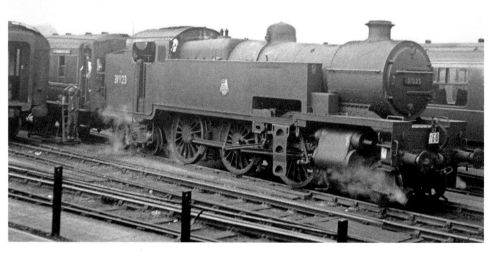

The empty stock of today's Bournemouth Belle on 2 September 1961 is prepared for service while W Class 2-6-4T 31923 warms the stock through before running up to Waterloo. (Frank Hornby)

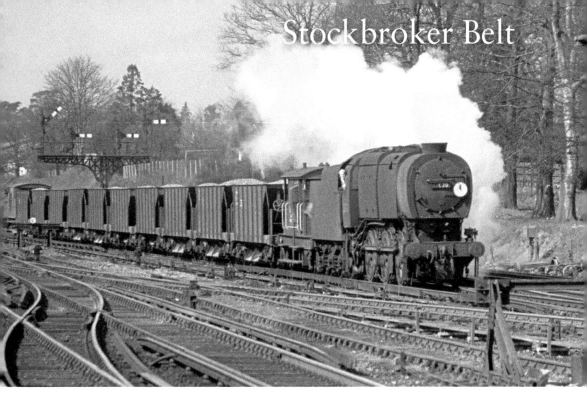

With chalk applied to highlight 33020's smoke box number in the original Bulleid style of numbering as C20, the powerful Q1 0-6-0 keeps a heavy ballast working moving through Wimbledon during 1965. (Strathwood Library Collection)

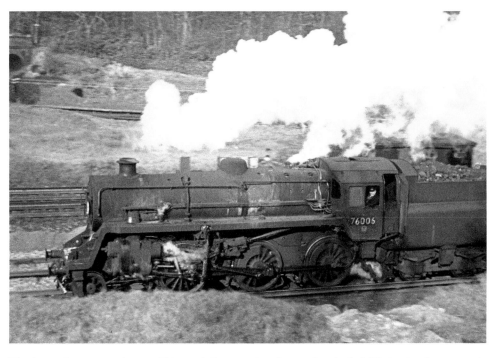

The driver glances towards us on Valentine's Day in 1967 as he gets Standard 4MT 76006 on her way again with the mid-day parcels from Weybridge. (John Green)

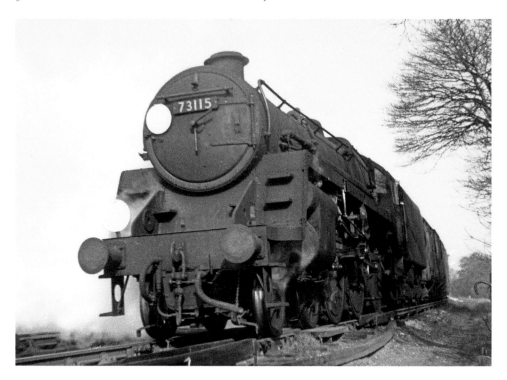

No longer wearing the attractive *King Pellinore* nameplates by 13 February 1967, Standard 5MT 73115 draws away from the Addleston starter heading west. (John Green)

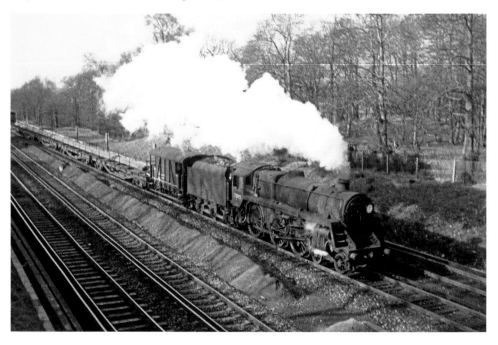

Much track renewal work was undertaken in connection with the electrification to Bournemouth in the mid-sixties. Engaged in such work is Standard 5MT 73092 at Weybridge on 24 February 1967; the locomotive is actually in lined green livery underneath all of that filth. (John Green)

The friendly signal man at Addlestone Junction exchanges greetings with the footplate crew of West Country 34098 *Templecombe* during his turn on 28 April 1967. (John Green)

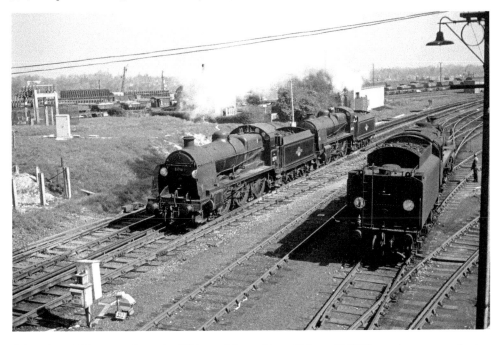

A Standard 5MT waits in the yard at Woking while a pairing of Maunsell's U Class 2-6-0s, 31791 and 31639, will make its way onwards light engine, having worked in the first leg of the RCTS Longmoor Railtour from Waterloo on the morning of 30 April 1966. (Late Norman Browne/Strathwood Library Collection)

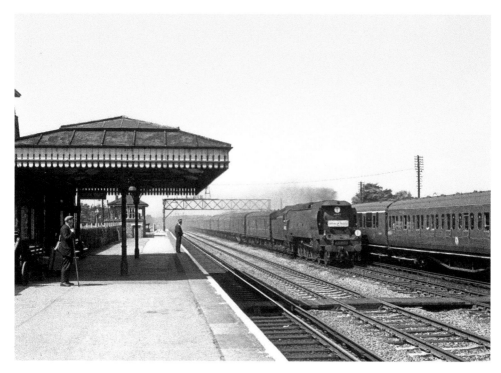

An up stopper made up of 2-BILs stands at Brookwood on 4 June 1965 while West Country 34103 *Calstock* races through on the up fast with a well-loaded Holland America boat train. (Strathwood Library Collection)

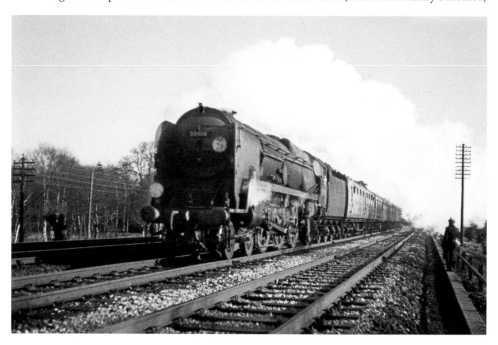

A railwayman makes his way along the concrete wiring conduits near Bramshott Halt on a chilly 5 February 1964 as a down Bournemouth service thunders past behind Merchant Navy 35018 *British India Line*. (Peter Simmonds)

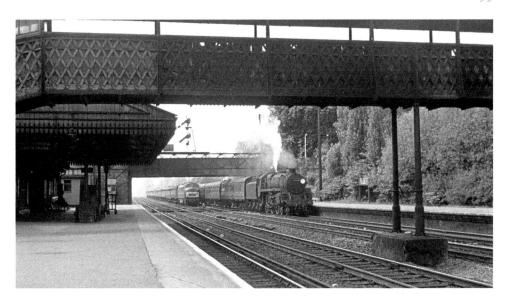

Standard 5MT 73018 is not likely to be taxed working the 13.12 Basingstoke to Waterloo as it pulls up for the Fleet stop just as D866 *Zebra* overtakes whilst in charge of the 10.30 Exeter to Waterloo on 4 June 1965. The signals are off for a down fast as well. (Strathwood Library Collection)

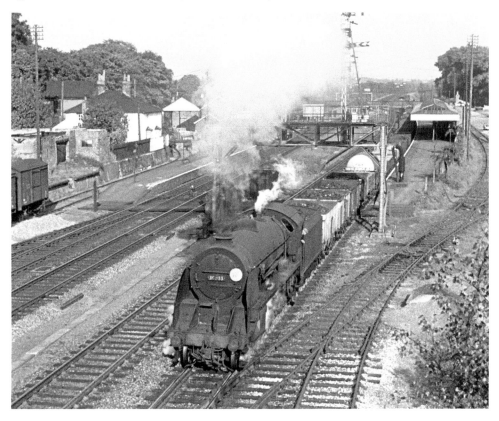

The driver listens out in pleasant sunshine as his Maunsell S15, 30833, works through Winchfield on a down freight on 12 September 1964. (Strathwood Library Collection)

Platform Ticket at Basingstoke

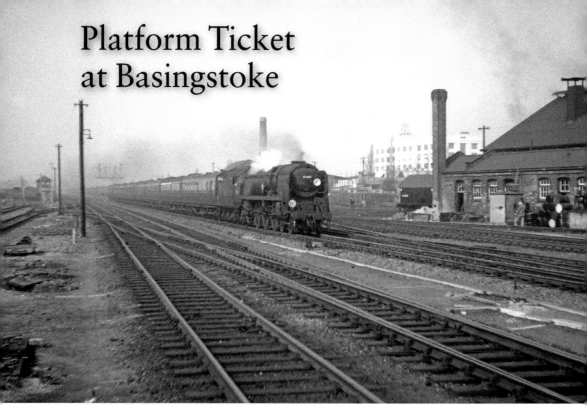

Running fast past the engine sheds at Basingstoke on 3 April 1965, Merchant Navy 35011 *General Steam Navigation* will most likely be right time on arrival at Waterloo. (Michael Beaton)

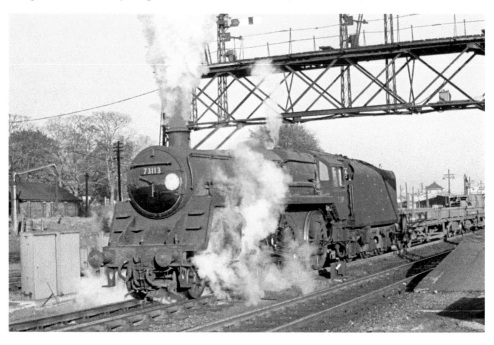

Putting on a little show of steam on this sunny October day in 1965, a shabby looking Standard 5MT 73113 *Lyonesse* makes a splendid sight getting away again from a signal check at Basingstoke. (Strathwood Library Collection)

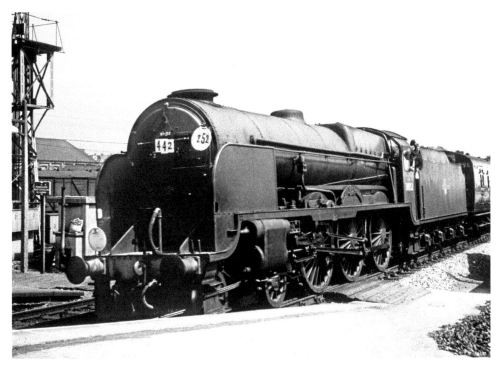

The footplate crew look out for their relief on arrival at Basingstoke, having brought in Lord Nelson 30852 *Sir Walter Raleigh* in 1960. (Trans Pennine Publishing)

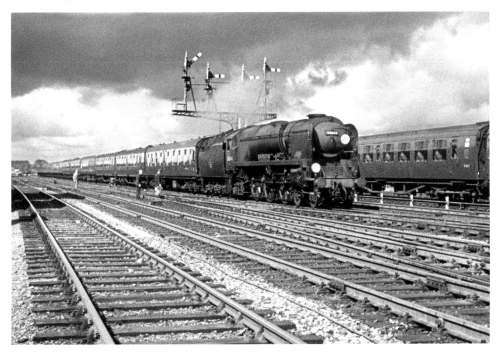

Storm clouds gather on a muggy August day during 1963 as the permanent way gang respectfully step back from their task to allow the passage of West Country 34044 *Woolacombe*. (Strathwood Library Collection)

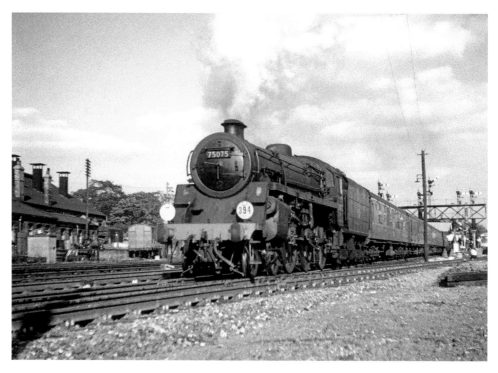

The double chimney of Standard 4MT 75075 rings out a loud exhaust note as the driver opens her up departing from a Basingstoke stop on 10 September 1966. (Michael Beaton)

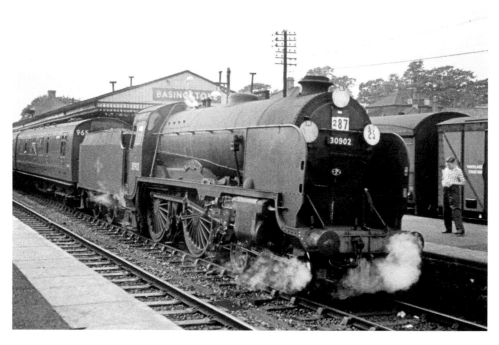

A young spotter watches the motion carefully on Maunsell's Schools 4-4-0 30902 *Wellington* on arrival in 1961. (Trans Pennine Publishing)

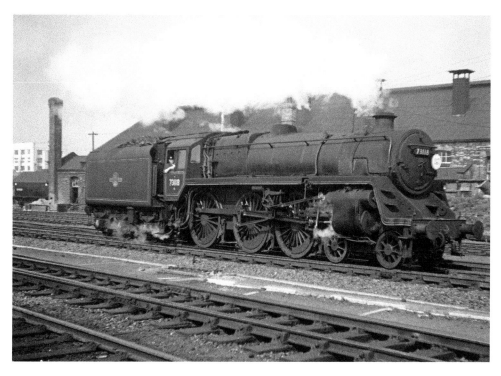

Running through the station light engine, sadly without nameplates anymore, on 3 April 1965 was Standard 5MT 73118 *King Leodegrance*. (Michael Beaton)

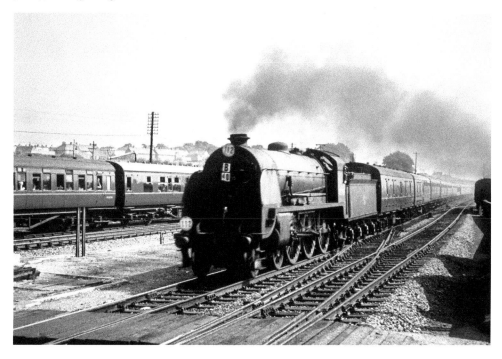

Still very active in 1961 was one of the last surviving Maunsell King Arthurs, 30765 *Sir Gareth*. The driver looks out from his steed to observe signals as he speeds into the station. (Trans Pennine Publishing)

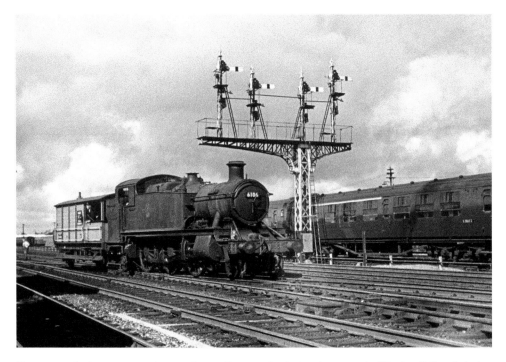

Bringing its brake van across the mainline at Basingstoke during August 1963, Charles Colletts's design of Prairie tank 6106 will make its way back to Western Region metals again via Bramley and Mortimer to Reading, without a return working. (Strathwood Library Collection)

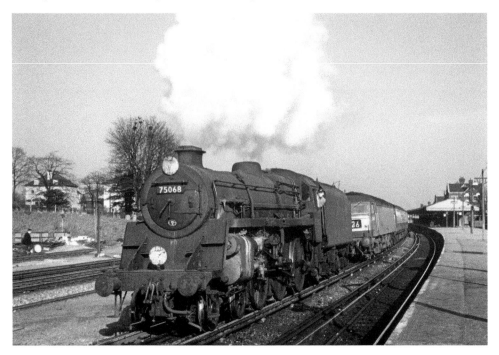

Standard 4MT 75068 comes off the front of Brush Type 4 D1922 on 21 March 1967, the diesel having come back to life again on arrival at Basingstoke. (Strathwood Library Collection)

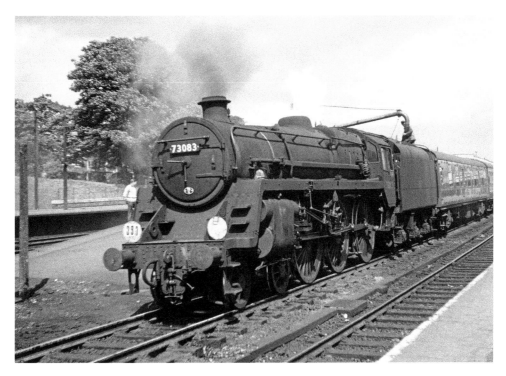

A Hymek hauled train alongside 73083 *Pendragon* on 19 June 1963 will get away before the Standard 5MT while water is taken. (Michael Beaton)

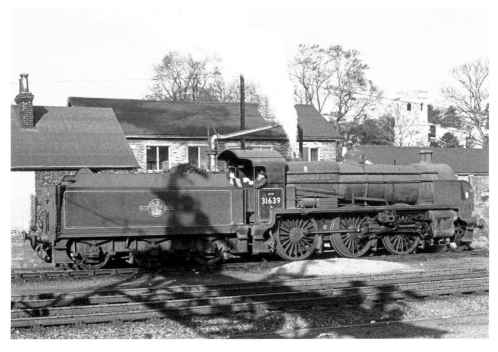

Both driver and fireman of Maunsell U Class 31639 look out before they set carefully back onto the shed in the early winter of 1965. (Strathwood Library Collection)

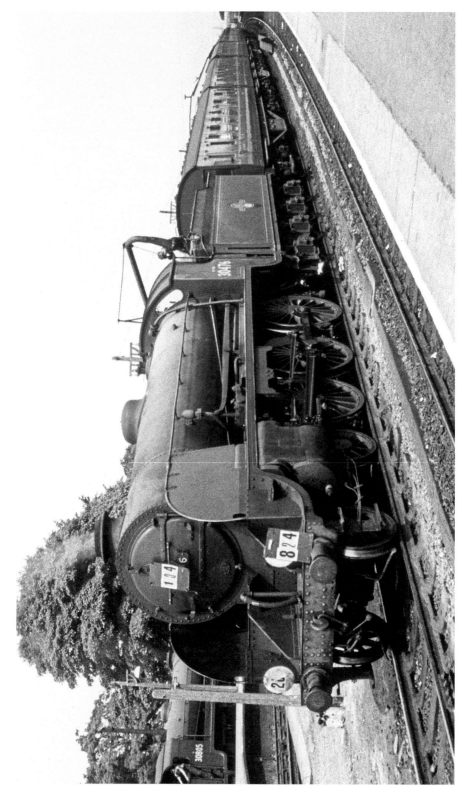

A tender refill for H15 4-6-0 30476 at the head of a rake of former London Midland & Scottish Railway coaching stock before the onward journey in 1959. (Trans Pennine Publishing)

A Ticket to Barnstaple

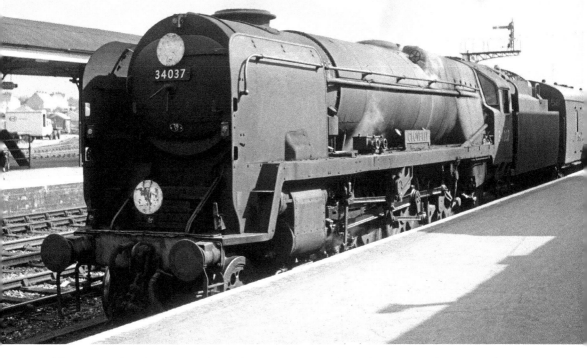

The goods yard in the background at Andover Junction was still very busy in 1965 while we wait for West Country 34037 *Clovelly* to be given the right away to head west. (Bob Treacher/Alton Model Centre)

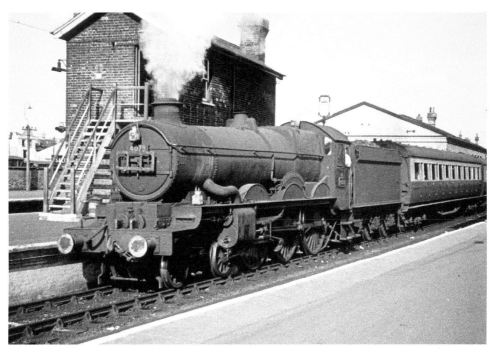

Backing out on departure from Salisbury in 1959 is 4078 *Pembroke Castle* in a very unkempt state whilst working in from the Western Region at Salisbury during 1959. (Trans Pennine Publishing)

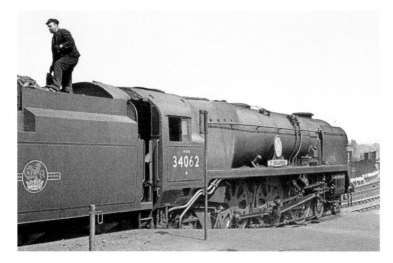

A chance to pull the coal forward on board Battle of Britain 34062 *17 Squadron* during the stop at Salisbury while working an up service in 1962.

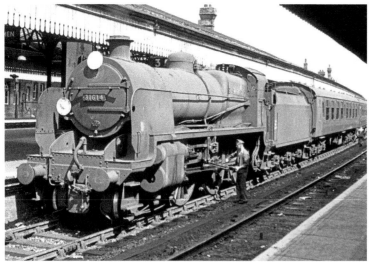

Checking the trimmings and oiling round while awaiting departure from Salisbury occupies the crew of Maunsell U Class 31614 on a warm day in 1963. (Trans Pennine Publishing)

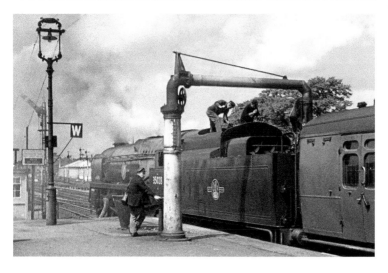

The relieved crew of Merchant Navy 35028 *Clan Line* stick around to assist their colleagues make up their engine for the next leg on the Atlantic Coast Express whilst taking water at Salisbury on 27 May 1963. (Strathwood Library Collection)

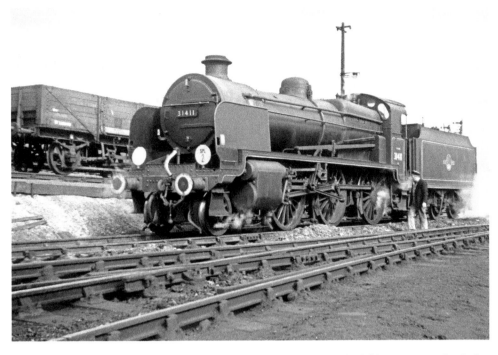

A careful look around his engine for the driver who has brought Maunsell's N Class 31411 onto the shed at Salisbury on 3 April 1966, having worked with 31639 from Waterloo with an LCGB special. (Strathwood Library Collection)

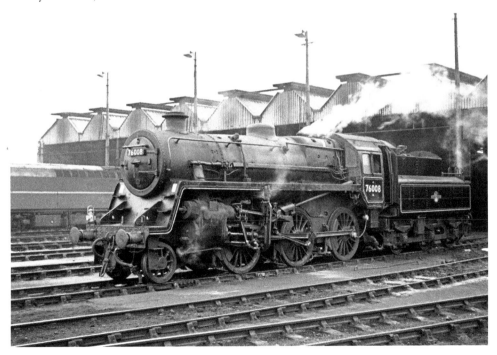

Although appearing well presented outside in the cold winter air on its home shed, 70E Salisbury, time is running out for Standard 4MT 76008 on 9 January 1966. (Strathwood Library Collection)

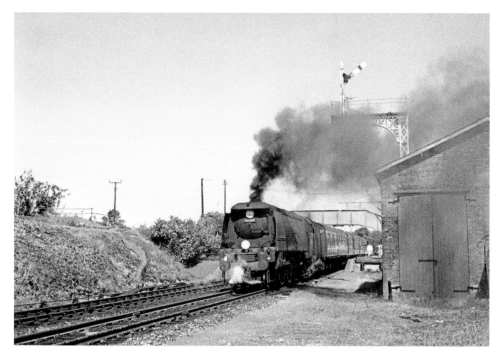

The track has already been lifted from the goods yard at Millborne Port by 1964 as West Country 34099 *Lynmouth* gets away with the 12.56 Salisbury to Yeovil stopper. Within two years trains will never call here again. (Strathwood Library Collection)

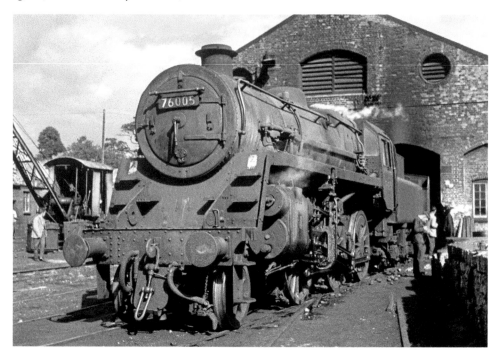

A society party makes their way around the small shed at Yeovil Town on 20 September 1964; one for the notebooks before rejoining the coach that day was Standard 4MT 76005. (Winston Cole)

Relaxed passengers sit outside in the sunshine whilst awaiting departure time for 0415 Class 4-4-2T 30583, in sight of the sea at Lyme Regis, in June 1959 before a run back to the mainline at Axminster. (Late Norman Browne/Strathwood Library Collection)

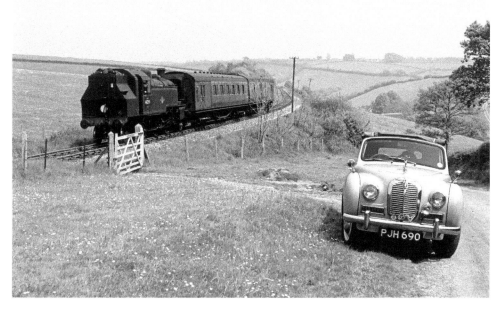

Successors to the Adams Radial Tanks were the Ivatt 2MT 2-6-2Ts such as 41291, also running bunker-first back to the mainline, past a truly splendid Austin, on 31 May 1963 near Combpyne. (Phil Nunn Collection)

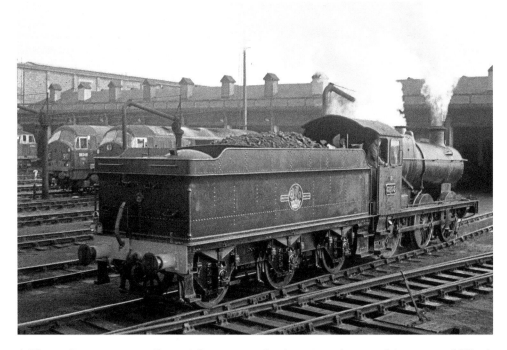

A Western Region invasion at Exmouth Junction on 2 October 1966, with a pair of the unsuccessful North British diesel hydraulics on hand to welcome the arrival of preserved Collett 0-6-0 3205 as the driver cautiously backs his engine out of the shed. (Dave Down)

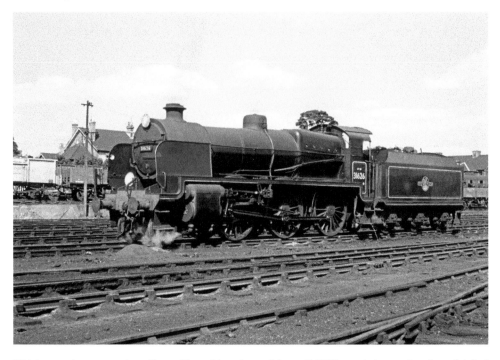

Waiting to take over a train at Exeter Central in 1962 was Maunsell U Class 31626, a product from Ashford Works in early 1929. (Trans Pennine Publishing)

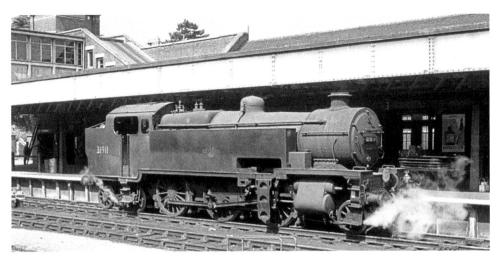

After a working life in south-east London, W Class 2-6-4T 31911 moved west for the last two years of its service career, much of it spent as a pilot working around Exeter Central as here in 1963 its last year in traffic. (Trans Pennine Publishing)

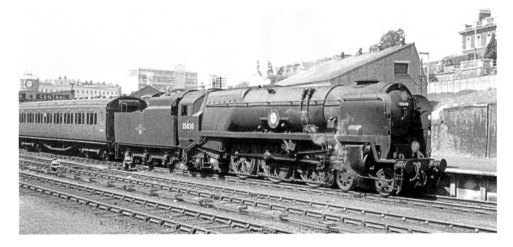

Above: Basking in the sun at Exeter Central in 1963 was Merchant Navy 35030 *Elder Dempster Lines*. (Trans Pennine Publishing)

Right: A light engine movement through Exeter Central for Standard 4MT 80036, on 17 May 1964. (Strathwood Library Collection)

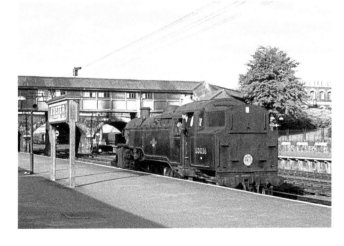

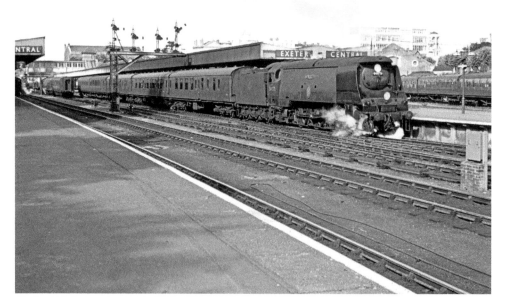

Moving out of the station in May 1963 with an easy load was Battle of Britain 34075 *264 Squadron*. (Trans Pennine Publishing)

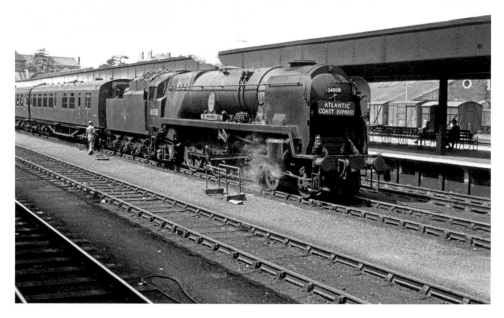

Making up its train while carrying the famous headboard from the ACE was fellow Battle of Britain 34058 *Sir Frederick Pile* on the same day. (Trans Pennine Publishing)

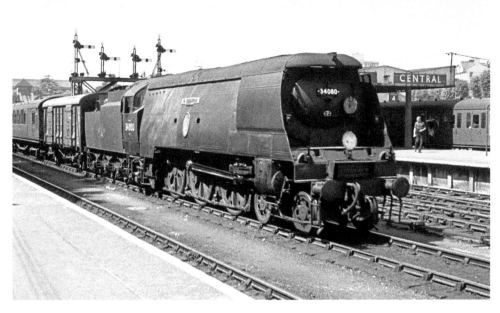

Further stock movements keep Battle of Britain 34080 *74 Squadron* occupied in the centre roads at Exeter Central, again in 1963. (Trans Pennine Publishing)

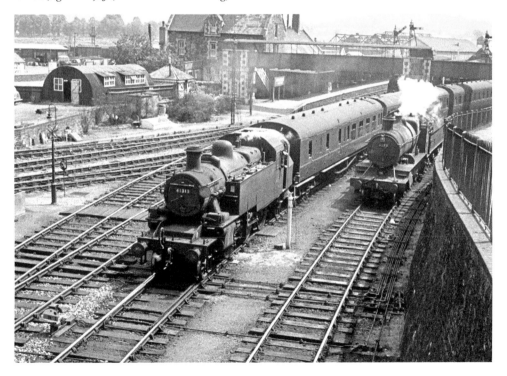

Ivatt 2MT 41313 and a Churchward Mogul are on hand as an unrebuilt Bulleid Pacific is signalled away from Barnstaple Junction in the background during 1963. (Trans Pennine Publishing)

On board behind West Country 34020 *Seaton* and Battle of Britain 34081 *92 Squadron* at Barnstaple from Ilfracombe on 22 June 1963. Barnstaple was once served from five directions in its heyday. (Strathwood Library Collection)

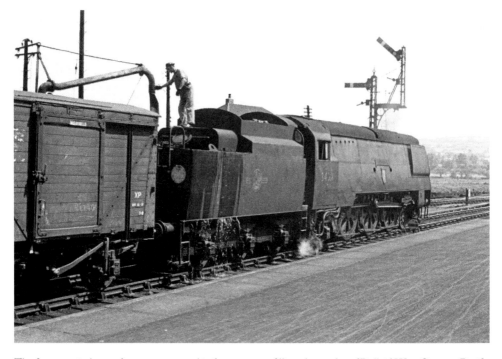

The fireman wisely stands so as not to get his feet wet over-filling the tender of Bulleid West Country Pacific 34011 *Tavistock* while standing at Barnstaple in 1962. (Trans Pennine Publishing)

Isle of Wight Sunset

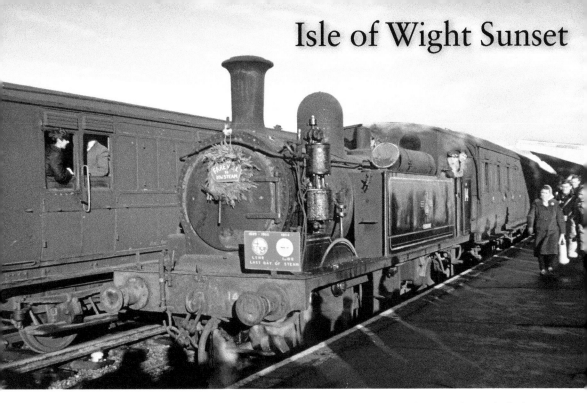

It is New Year's Eve at Shanklin and the low winter sun highlights the shadows and brings a glint to the flanks of Adams Class O2 0-4-4T 14 *Fishbourne* at Shanklin on the last day of regular steam services for the island on 31 December 1966. (Chris Forrest)

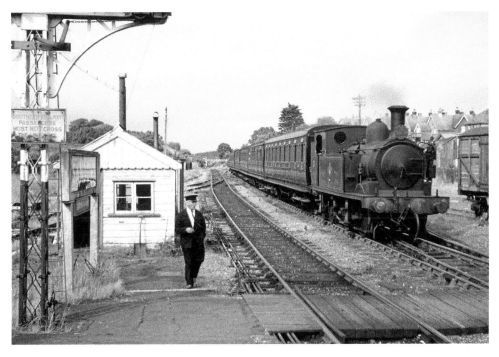

A brisk wind is running up the Solent on the afternoon of 9 July 1966 as Class O2 0-4-4T 31 *Chale* arrives at Sandown with the 16.40 Ryde Pier Head to Shanklin. (Stewart Blencowe Collection)

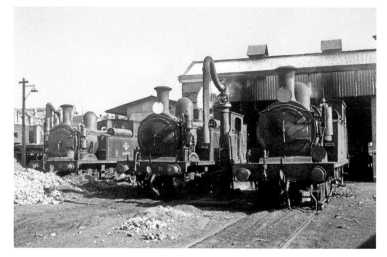

We would be sure all railway enthusiast day trippers to the Isle of Wight would make a visit to 70H Ryde. Our visitor on 1 September 1965 was greeted by 17 *Seaview*, 22 *Brading* and 26 *Whitwell* in this penultimate year for steam on the island. (Dave Down)

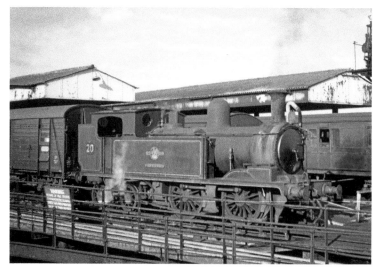

The smokebox of 20 *Shanklin* suggests some hard working and a build up of ash when seen on Ryde Pier Head on the last day of August 1965. (Strathwood Library Collection)

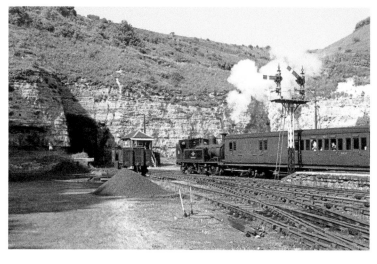

Getting away from Ventnor bunker-first into the tunnel towards the first stop at Wroxall on 2 June 1963 is Adams Tank 35 *Freshwater*, one of the last two Class O2s to arrive in April 1949 from the mainland. (Strathwood Library Collection)

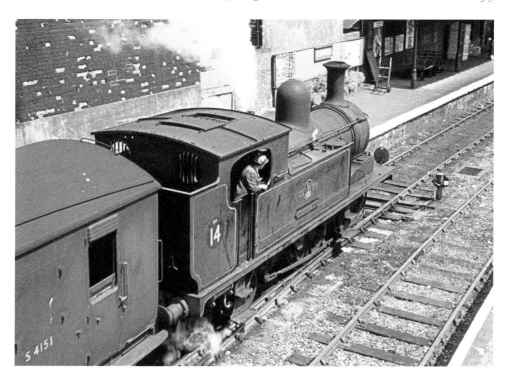

A gentle run into the terminus at Cowes from Newport for 14 *Fishbourne* during 1965. (Trans Pennine Publishing)

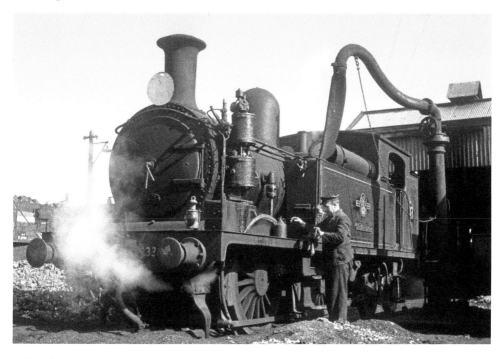

All is well under control on 30 August 1965 as the bag is in the tanks slowly filling up 33 *Bembridge* on shed at Ryde, while the driver oils round his engine. (Dave Down)

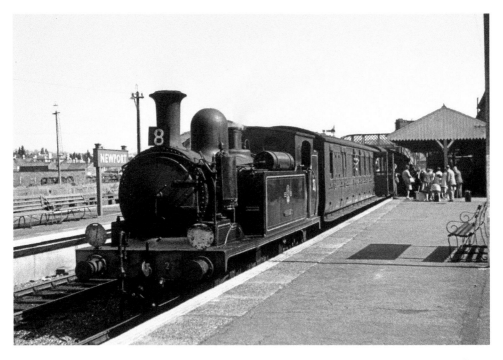

The Cowes train is in the hands of 27 *Merstone* on 1 June 1963 at Newport as the shadows lengthen. (Peter Simmonds)

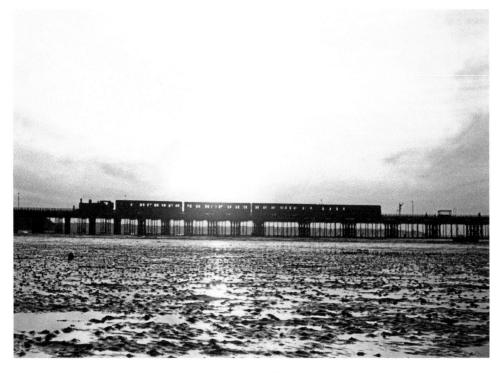

Highlighted against the afternoon sun whilst running along Ryde Pier on 29 August 1965, Class O2 0-4-4T 28 *Ashey* caught the attentions of our cameraman. (Dave Down)

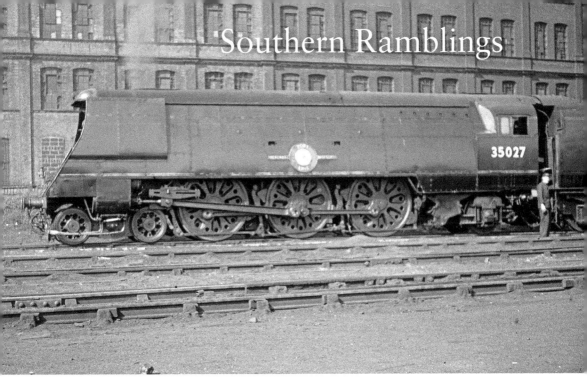

Southern Ramblings

In original as built condition Bulleid's Merchant Navy 35027 *Port Line* certainly cut an impressive line whilst being prepared at Stewart Lane in 1950, even if the lining was wearing off the blue paintwork. (Strathwood Library Collection)

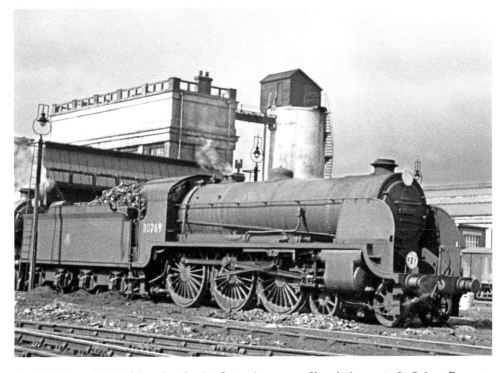

Ready for the road with a full tender of coal in September 1957 was King Arthur 30769 *Sir Balan* at Ramsgate shed for a run back to the capital. (Alan Pike O.B.E.)

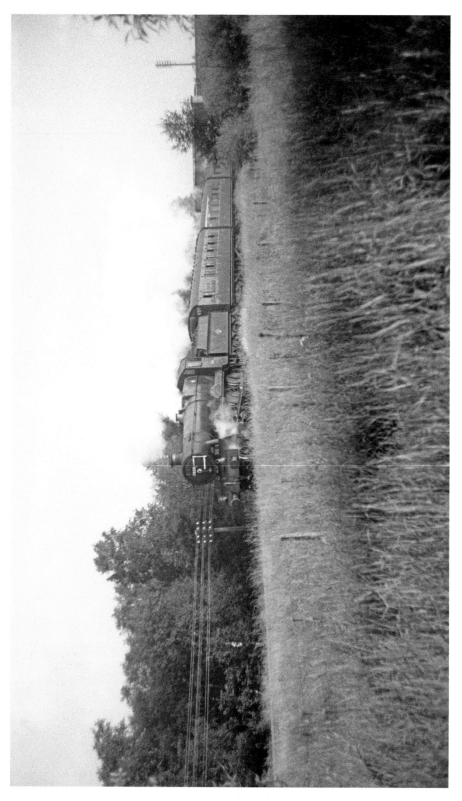

Both Churchward Moguls and Collett's Manors would make forays as far as Redhill from Reading. One such jaunt is being made by 7808 *Cookham Manor* during May of 1964, captured near Ash on this important cross country route. (Late Norman Browne/Strathwood Library Collection)

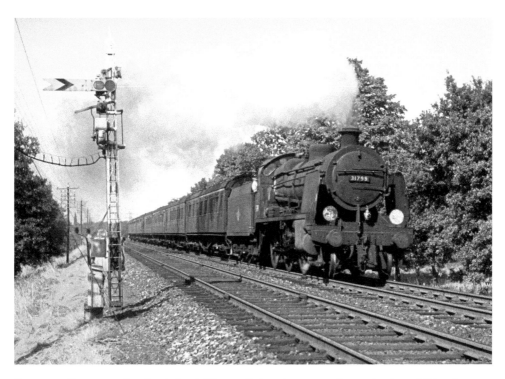

Running well past an ex London & South Western Railway lattice post distant signal near Wokingham was U Class 31799 in the late summer of 1964. (Ken Pullin)

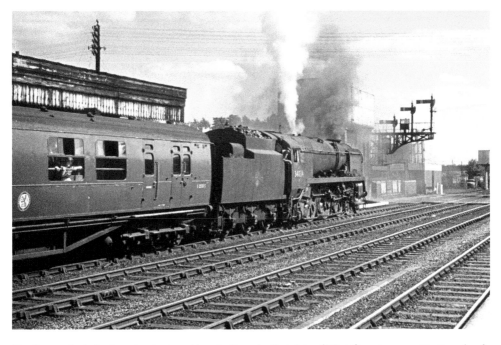

The fireman looks back anxiously along his train from the footplate of West Country 34034 *Honiton*, already stripped of its nameplates, at Oxford having taken over the 08.30 Newcastle to Bournemouth on 7 August 1965. (Strathwood Library Collection)

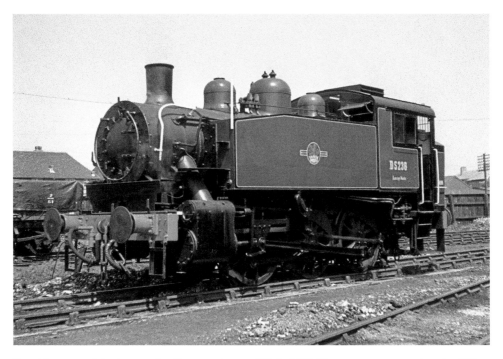

Lavishly repainted for duties within Lancing Carriage Works, USA Class 30074 was renumbered as DS236 and given this attractive green livery in April 1963. (Peter Simmonds)

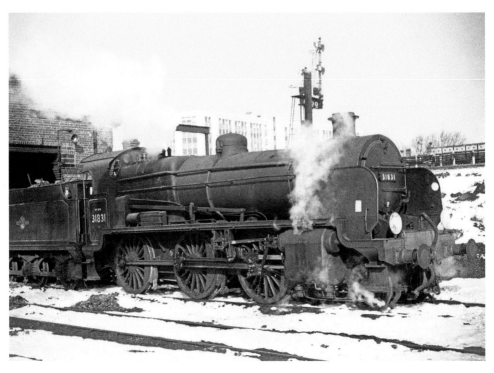

A light snow fall followed by some crisp sunshine makes a pleasant stage for Maunsell N Class 31831, all ready for duty outside the Southern Region shed at Reading during 1964. (Bob Treacher/Alton Model Centre)

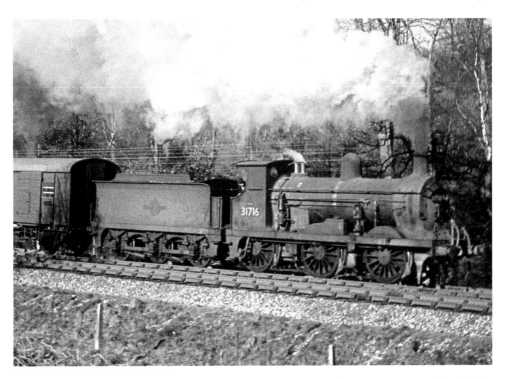

Pulling well near Langton Green in February 1961 is C Class 0-6-0 31716. The engine was one of a batch built by Sharp Stewart & Co. sixty years previously in January 1901. (Strathwood Library Collection)

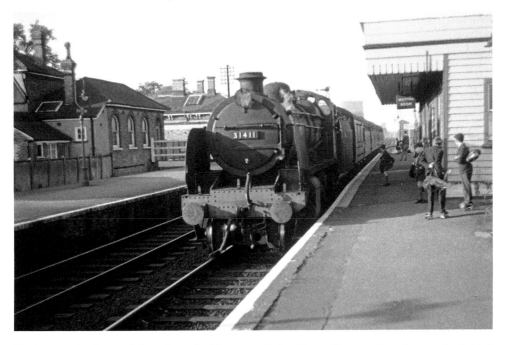

Hardwearing leather satchels at the ready, this group of school boys will get a ride to classes today behind N Class 31411 as it pulls up for the North Camp stop in October 1964; hopefully they will not be late! (Late Norman Browne/Strathwood Library Collection)

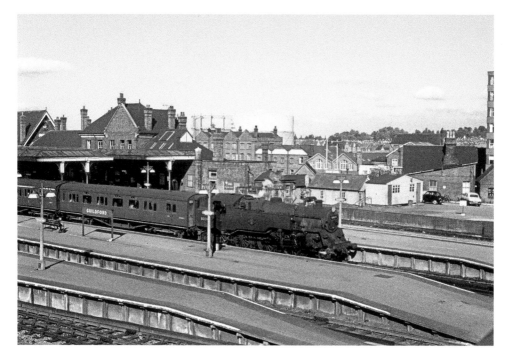

Early afternoon on 26 September 1964 and Standard 4MT 80139 waits at Guildford whilst working the 13.50 Reading to Redhill. (Strathwood Library Collection)

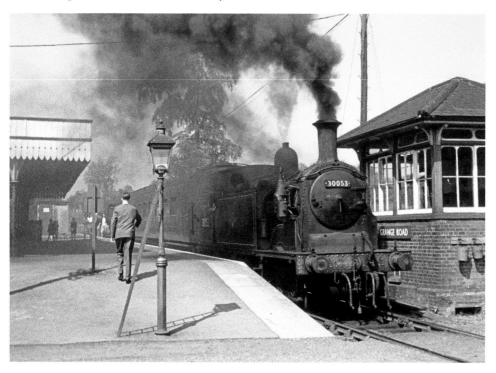

Passenger activity at Grange Road on 8 June 1963 for M7 Class 0-4-4T 30053 with an East Grinstead train. (Peter Simmonds)

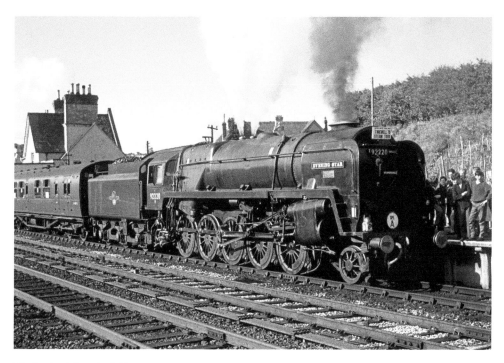

The last built Standard 9F, 92220 *Evening Star*, is starting to ramp a bit at the safety valves during a ten-minute stop at Seaton Junction on 20 September 1964 at the head of the SCTS Farewell to Steam Tour. (Strathwood Library Collection)

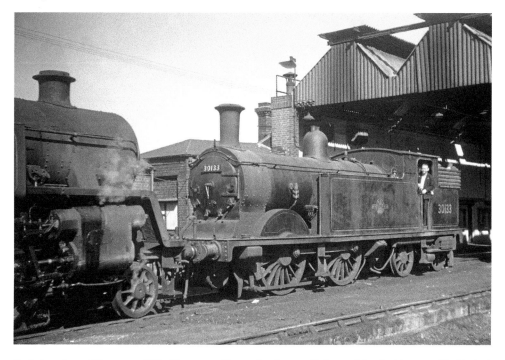

Early in 1964 and Drummond M7 Class 0-4-4T 30133 has been pulled out of the shed by some kindly shed staff at Tunbridge Wells West to allow a photograph to be taken in sunshine. (Len Smith)

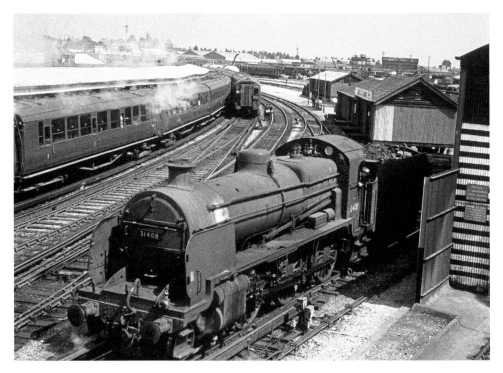

A busy moment at Fratton Park on 14 August 1965 as Maunsell N Class 31408 goes about its business in the company of 2-BIL and 4-COR electric sets. (Strathwood Library Collection)

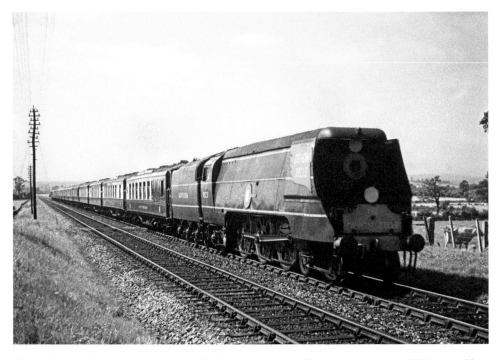

The up Devon Belle Pullman service is well loaded in July 1947 near Semley with six-year-old Merchant Navy 21C3 *Royal Mail* at its head today with all of the embellishments in use at the time. (Ken Pullen)

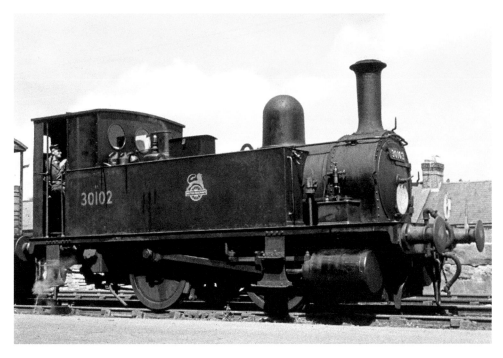

The powerful but short wheel base Class B4 0-4-0T 30102 was on hand at Winchester in 1963 to assist with shunting the tightly curved lines into the goods yard here. (Strathwood Library Collection)

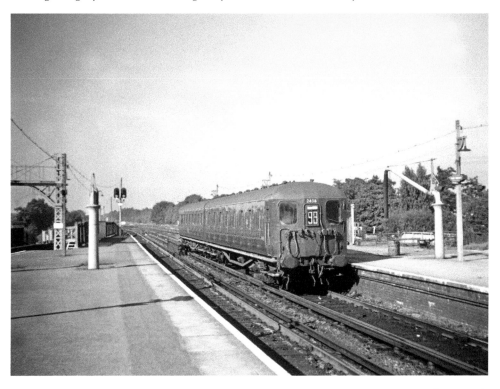

One of the Bulleid designed 2-HAL units, 2636, drifts to a halt at Three Bridges in September 1963. (Len Smith)

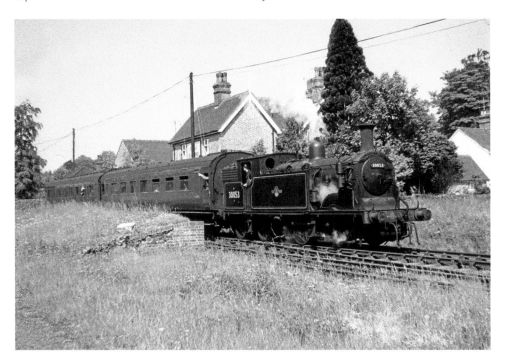

Another view of M7 Class 0-4-4T 30053 on 8 June 1963, departing from Grange Road for East Grinstead on the route from Three Bridges. (Peter Simmonds)

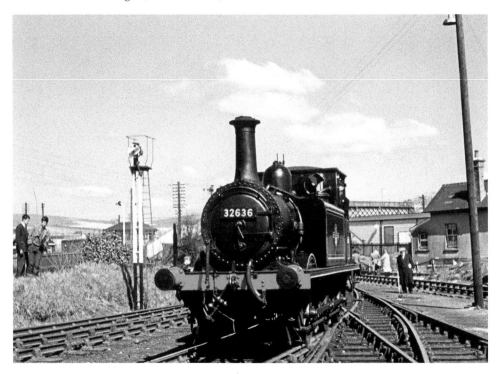

Enthusiasts gather trackside at Newhaven during May 1958 as A1X Class 0-6-0T 32636 runs around the shed yard. (Strathwood Library Collection)

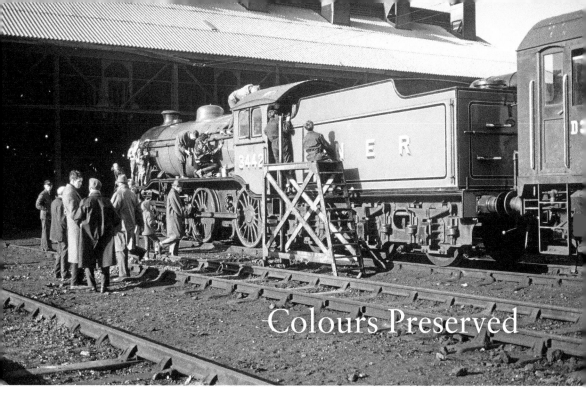

Colours Preserved

The smell of kerosene is in the air as the Gresley K4 Class 3442 *The Great Marquess* is being cleaned for duty on a special that morning on shed at Nine Elms on 11 March 1967. (Frank Hornby)

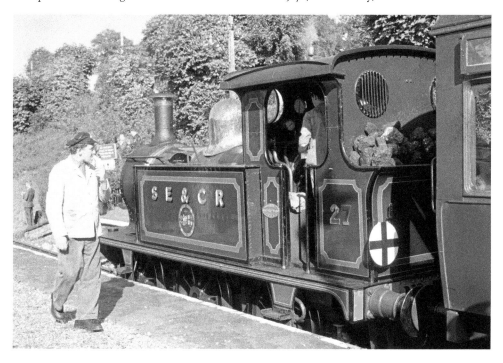

This railwayman has a draw on his pipe whilst admiring P Class 27, repainted into South Eastern & Chatham Railway colours once more at Horsted Keynes on 15 September 1963. (Strathwood Library Collection)

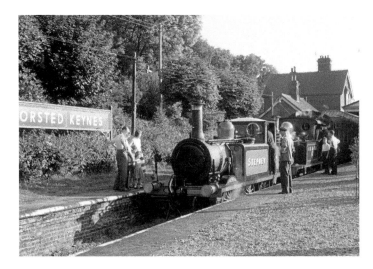

The former 32655, back now as *Stepney* with its original identity in London Brighton & South Coast Railway livery, has backed onto 27 on 15 September 1963, for a double headed train along the Bluebell Railway to Sheffield Park. (Strathwood Library Collection)

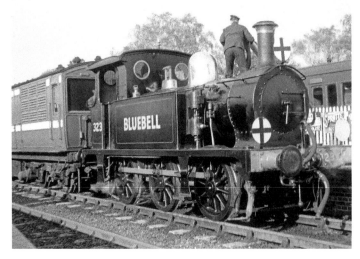

Water is being taken for the former British Railways P Class 31323 at Sheffield Park, now well preserved in the Bluebell Railway's own colour scheme as 323 *Bluebell* on 13 October 1963. (Frank Hornby)

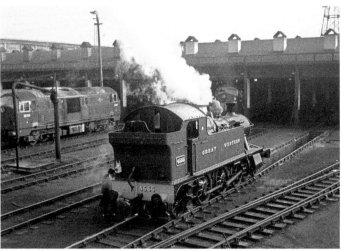

The fireman is up on the boiler casing watching the flow of water into the tanks of the preserved Churchward Prairie 4555 in a visit to Exmouth Junction on 2 October 1966. (Dave Down)

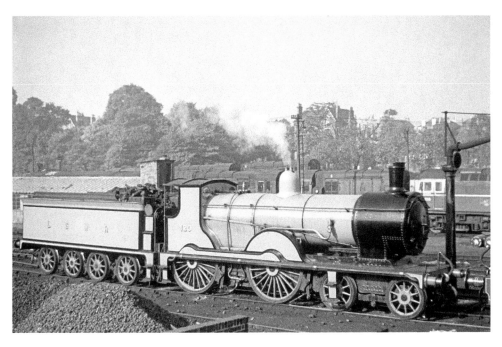

Being prepared at Norwood Junction for a run with the Caledonian Single 123 on that glorious morning of 15 September 1963 was Class T9 120 to double head The Blue Belle special and a run to the Bluebell Railway to meet up with the line's preserved steam locomotives. (Strathwood Library Collection)

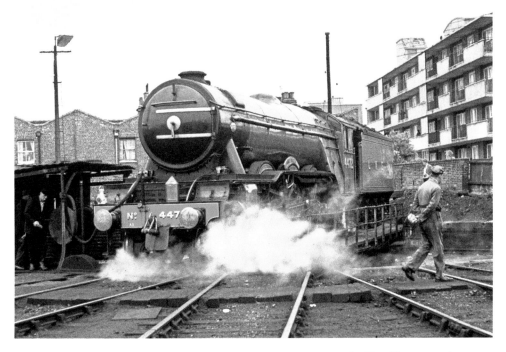

Alan Pegler takes a walk around the turntable whilst his engine is being turned at Nine Elms in 1964 during one of *Flying Scotsman*'s many visits to the Southern Region in the mid-sixties. (Strathwood Library Collection)

Island Terriers

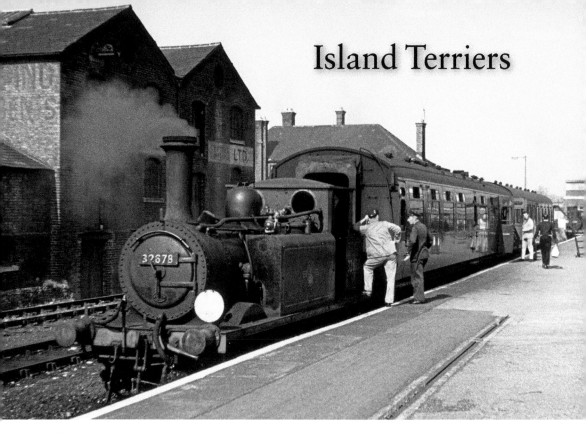

All very relaxed at Havant for Terrier 32678 before departure to Hayling Island on 1 June 1963. (Peter Simmonds)

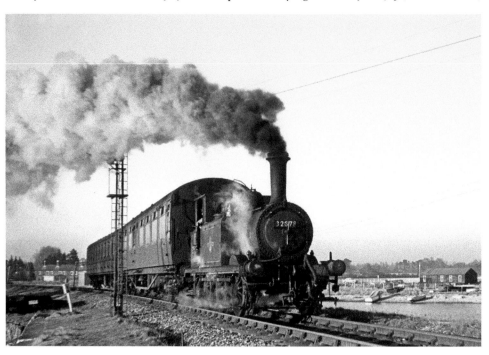

Steam has been shut off for the speed restriction across the Langstone Bridge on board 32678 in the early summer of 1963. (Peter Simmonds)

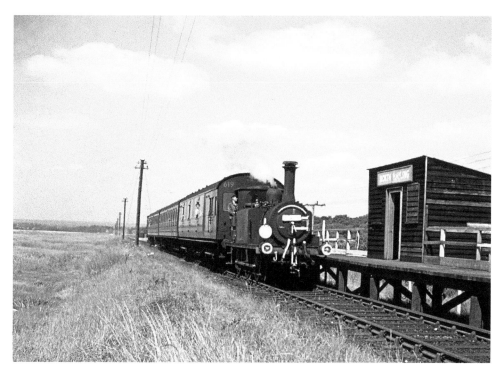

On a visit in 1962 it looks like there are no passengers to pick up at North Hayling as 32646 approaches. (Late Vincent Heckford/Strathwood Library Collection)

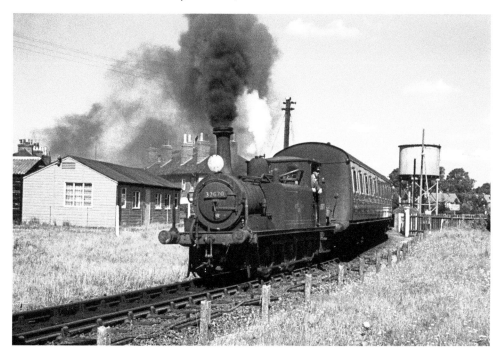

Once again in 1962 and 32670 is in service on the branch and all looks to be well under control near Havant. (Late Vincent Heckford/Strathwood Library Collection)

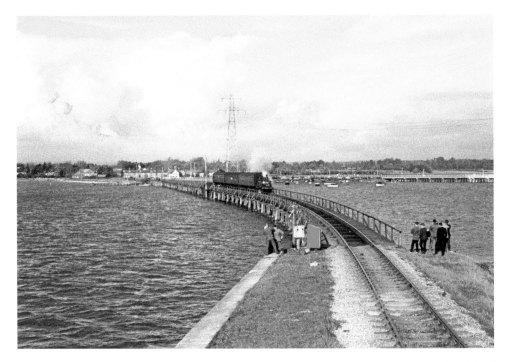

Cameramen seek the best angle to record 32650 as it comes off the bridge and onto the Hayling Island causeway in 1963; note the fire hydrant in red to deal with any fires from sparks on the timber trestle bridge. (Strathwood Library Collection)

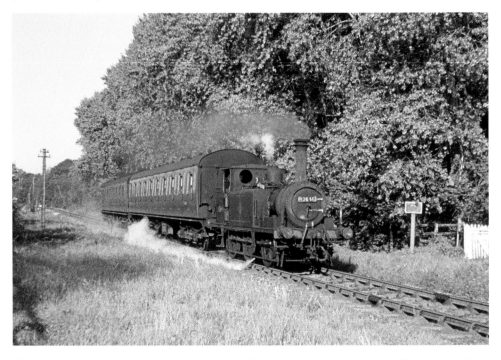

The end of the last summer season approaches for the line and with just two months until closure 32646 is at work between Havant and Langstone on 14 September 1963. (Peter Simmonds)

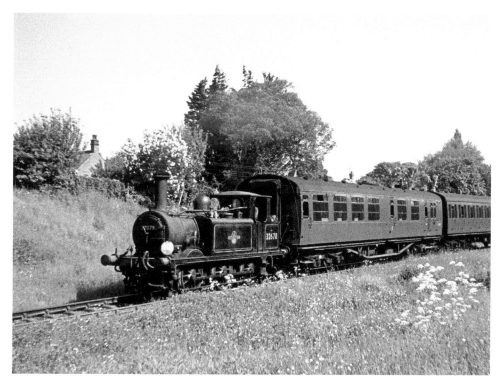

The wild flowers and blossom add to this view on 15 June 1963 of 32678 near Hayling Island. (Peter Simmonds)

Ready to give up the tablet on 31 August 1963 as 32646 nears Langstone Halt with a Havant to Hayling Island train. (Peter Simmonds)

Focus on Eastleigh

In between rain showers on a blustery day in 1966 West Country 34098 *Templecombe* runs fast on the down through road at Eastleigh. (Michael Beaton)

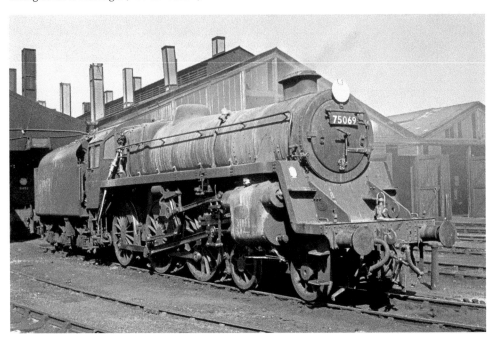

Looking very lime stained, perhaps from working frequently in the Reading area which is notorious for limescale in its water supplies, Standard 4MT 75069 stands outside in the warm spring sunshine at the locomotive sheds at Eastleigh in 1965. (Bob Treacher/Alton Model Centre)

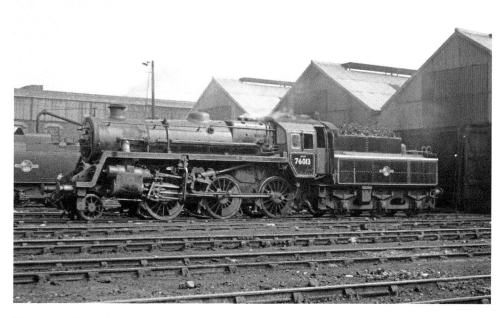

Five years earlier and cleaners have been keeping Standard 4MT 76013 up to scratch when it was seen on 26 March 1960. (Frank Hornby)

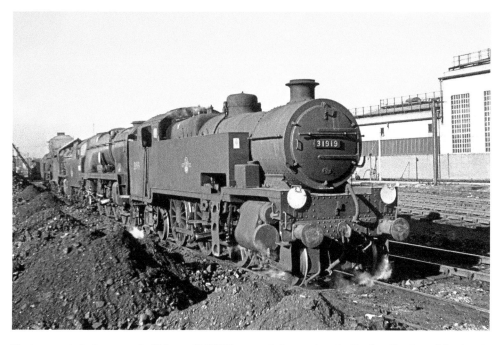

During a period when several of Maunsell's W Class were being used on the Fawley oil trains in March 1963, 31919 keeps mixed company in the shed yard; nine months later it will be inside the works here to be broken up. (Peter Simmonds)

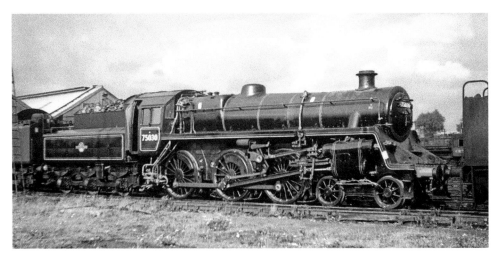

Fresh from the workshops after overhaul on 11 September 1965 was Standard 4MT 75030, coaled and ready for service once more. (Michael Beaton)

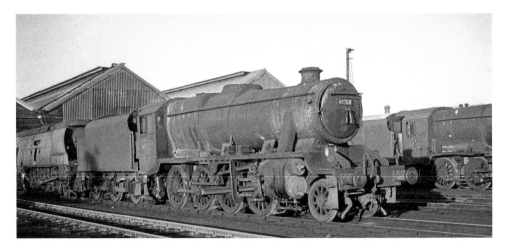

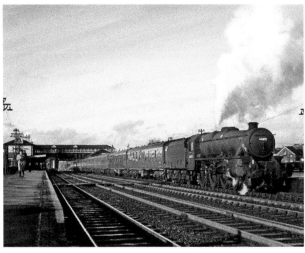

Above: Sent south from 16A Toton for a works overhaul in November 1964 in November 1964 was Stanier 8F 48700, although its future looks grim when you look at the withdrawn Battle of Britain 34054 *Lord Beaverbrook*, with its nameplates and crest crudely cut out, stabled behind the 2-8-0. (Late Norman Browne/Strathwood Library Collection)

Left: More Stanier steam at Eastleigh with Black Five 44872 on 26 March 1966 in charge of the last leg of the 10.08 York to Poole. (Strathwood Library Collection)

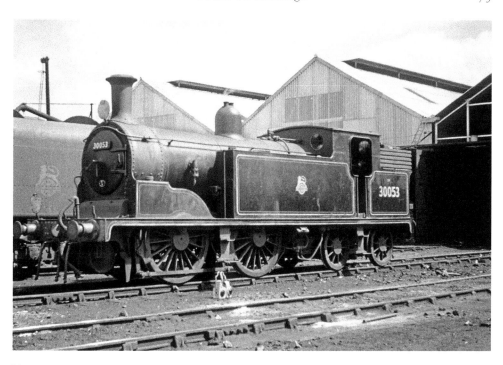

This time we find Drummond M7 0-4-4T 30053 in the earlier British Railways livery simmering quietly outside the locomotive sheds in 1958. (Trans Pennine Publishing)

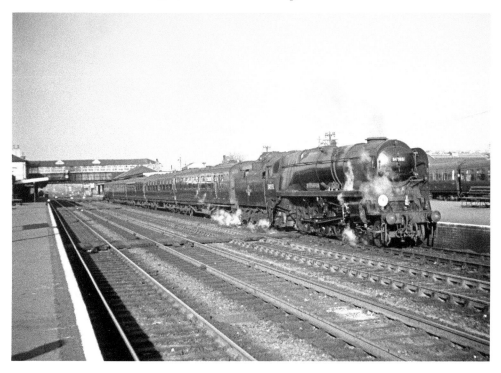

Recently cleaned and finding employment on a down stopping service was West Country 34093 *Saunton* in 1964. (Len Smith)

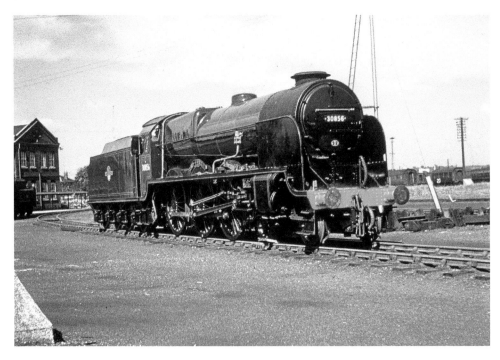

A return to traffic very soon for Lord Nelson 30856 *Lord St. Vincent*, standing on 18 September 1960 outside in the works. (Strathwood Library Collection)

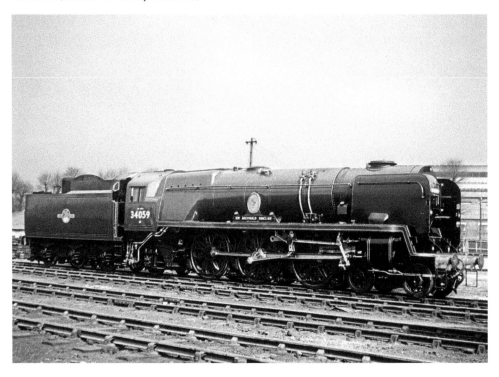

Also ex works in 1960 and ready to resume work was an immaculate Battle of Britain 34059 *Sir Archibald Sinclair* on 26 March. (Frank Hornby)

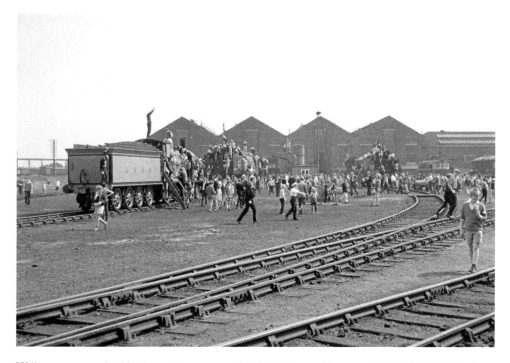

Will we ever see sights like this again at an open day? Probably not. However at the Eastleigh Works Open Day in 1962 things were very much more relaxed than they would be not so many years later. (Late Norman Browne/Strathwood Library Collection)

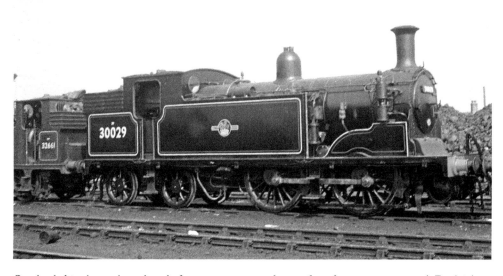

Overhauled in the works and ready for a return to everyday use for a few more years at 71A Eastleigh on 26 March 1960 was M7 Class 0-4-4T 30029. (Frank Hornby)

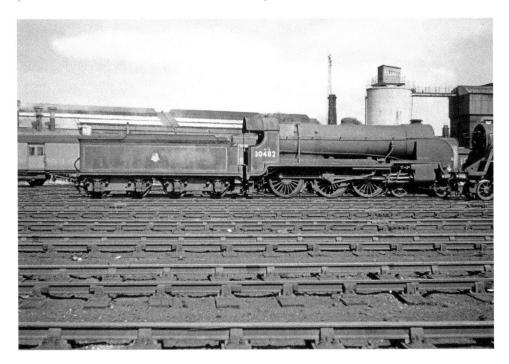

Recently withdrawn in May 1959, H15 Class 4-6-0 30482 has arrived to be broken up within the works yard within the next few months. (Trans Pennine Publishing)

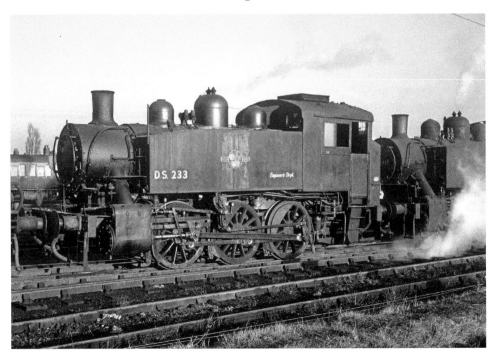

The former 30061 had been taken into Departmental Stock in 1962 and given the new identity of DS233; when seen on 2 January 1965 another two years' use would be found for this USA Class 0-6-0T. (Late Norman Browne/Strathwood Library Collection)

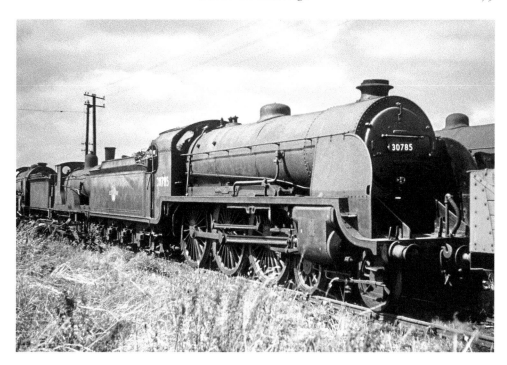

It is October 1959 and King Arthur 30785 *Sir Mador de la Porte* has just been posted as withdrawn and it waits in the works reception lines. Within the next month it would be no more as it passed to the scrap roads very quickly. (Trans Pennine Publishing)

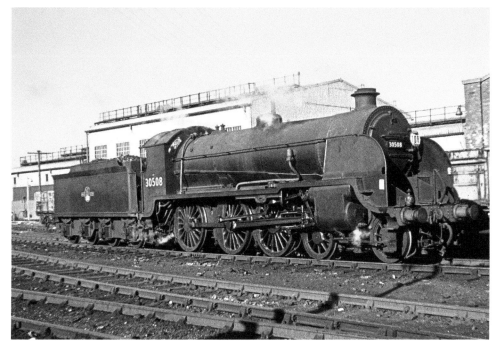

One of the Urie designed Class S15 4-6-0s, 30508, strikes a fine pose in the shed yard on 2 March 1963. (Peter Simmonds)

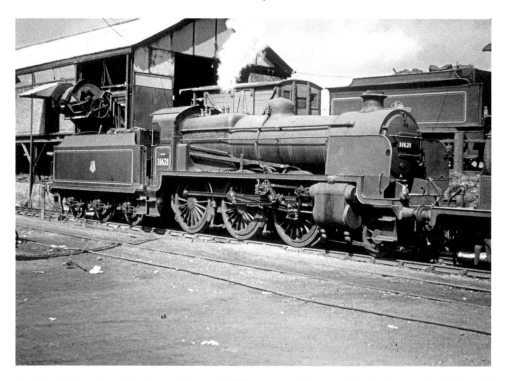

Standing in the coal road during 1958, Maunsell U Class 31621 still has a good head of steam in her boiler and may need the use of the injectors to keep her quiet shortly. (Trans Pennine Publishing)

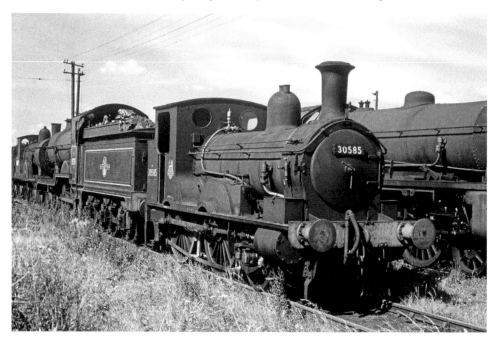

Built by Beyer Peacock in 1874, one of the last three Beattie Well Tanks 30585 stands in the works reception roads ominously with some 4-4-0s that would be less fortunate as they would be broken up in the works here, although the 2-4-0T would be reprieved. (Strathwood Library Collection)

Southampton Waters

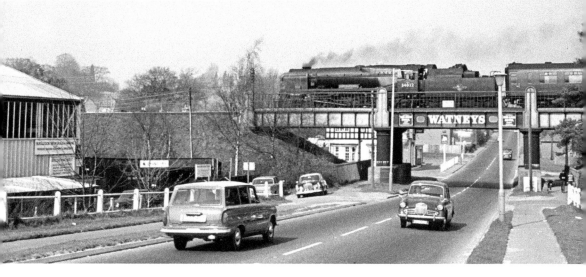

A very sixties timepiece was recorded at Bursledon on 20 March 1966, with road traffic and pedestrians most likely taking no notice of the sight, soon to disappear, before them of West Country 34032 *Camelford* rumbling with the 09.30 Waterloo to Bournemouth across the girder bridge. (Strathwood Library Collection)

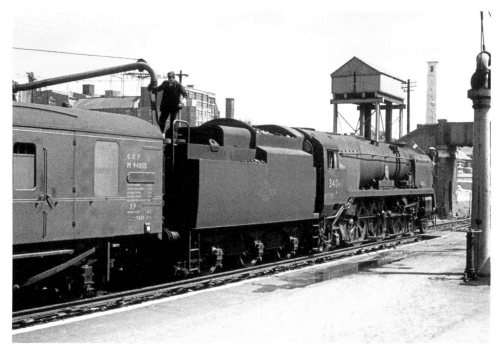

The starting signal is off but water is still being taken by 34040 *Crewkerne* at Southampton Central in 1965. (Trans Pennine Publishing)

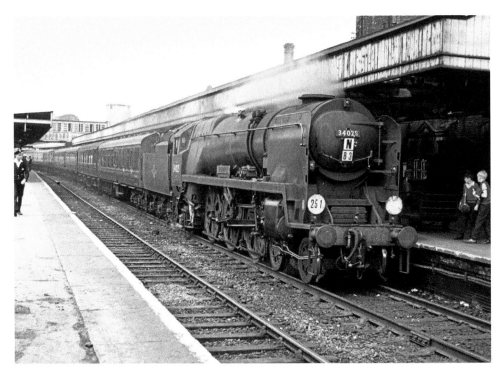

A porter paces alongside and spotters watch the arrival of 34025 *Whimple* into Southampton Central during 1965. (Trans Pennine Publishing)

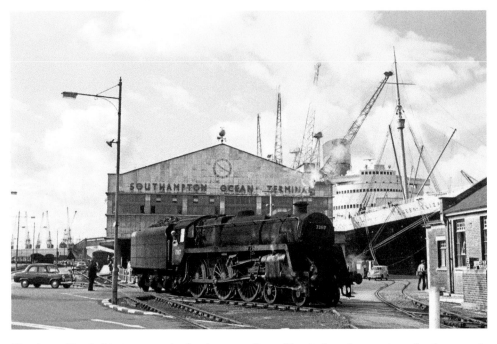

The *Queen Elizabeth* is in port at the Southampton Ocean Terminal on the morning of 31 August 1965 as a Ford Popular is halted to allow Standard 5MT 73117 *Vivien* free passage through the docks complex. (Strathwood Library Collection)

One of the Class E2 0-6-0Ts, 32109, brings some squealing trucks through Southampton Docks on 17 July 1960. (Strathwood Library Collection)

Three Americans who stayed after the war, USA 0-6-0Ts 30067, 30069 and 30064, back away through the docks on 19 June 1965. (Stewart Blencowe Collection)

The effects of hard cleaning have burnished back the paintwork to the primer on West Country 34032 *Camelford*'s smoke deflectors when seen departing from Southampton Central on 24 June 1966. (Michael Beaton)

Dorset Destinations

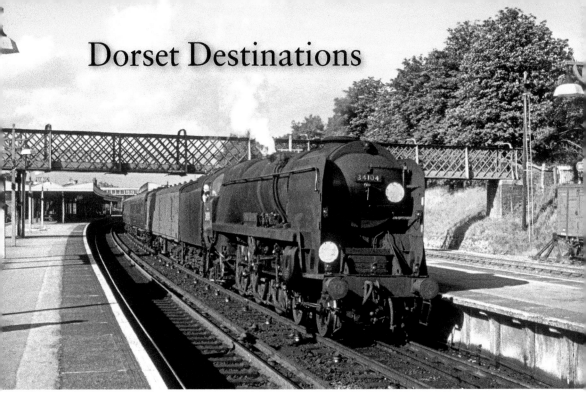

No such cleaning attentions have been bestowed upon fellow West Country 34104 *Bere Alston* at Brockenhurst in June 1966, also heading for Bournemouth. (Strathwood Library Collection)

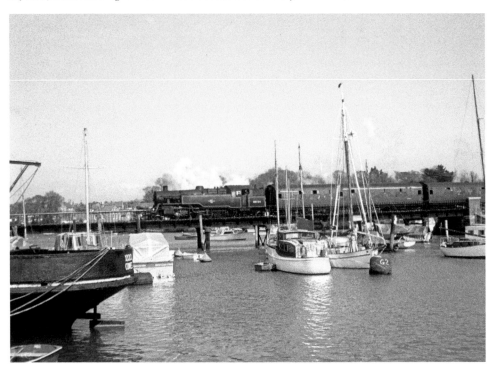

The sounds of seagulls and the gentle slapping of water against the boats moored in Lymington Harbour are briefly drowned out by the exhaust of Standard 4MT 80134, departing on 25 March 1967. (Peter Simmonds)

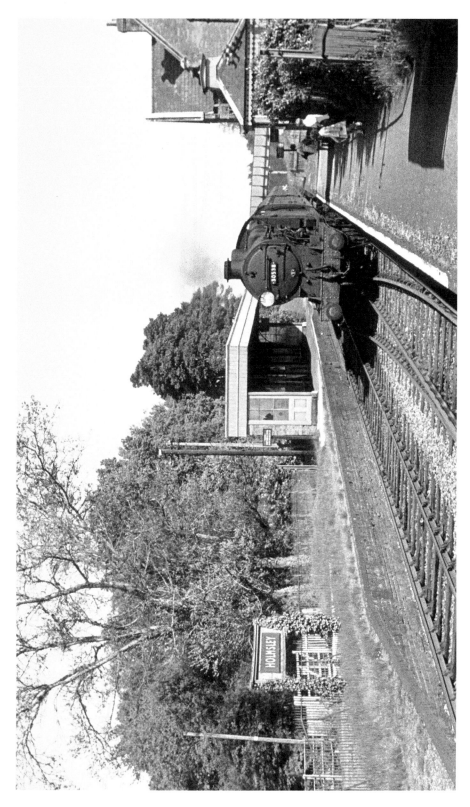

Several passengers are on hand to greet the arrival of Maunsell Q Class 0-6-0 30538 at Holmsley on 31 May 1963 for the 16.07 Brockenhurst to Bournemouth West. (Strathwood Library Collection)

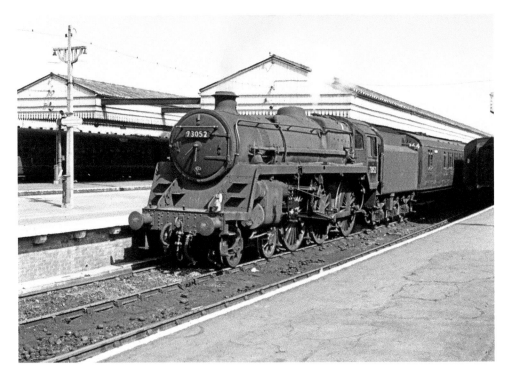

One of the regulars on the Somerset and Dorset line to Bath Green Park, Standard 5MT 73052, waits at Bournemouth West during 1962. (Trans Pennine Publishing)

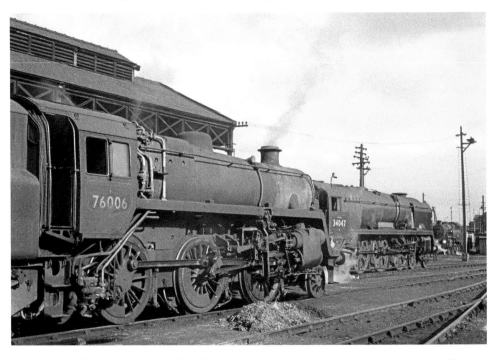

In Bournemouth's shed yard in 1965, West Country 34047 *Callington* is surrounded by Standard 4MT power with Mogul 76006 nearest the camera. (Win Wall/Strathwood Library Collection)

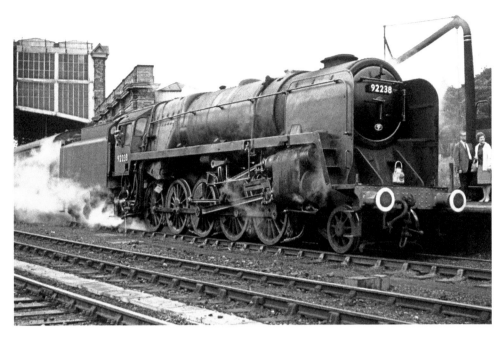

The fireman checks the operation of his Standard 9F's injectors before 92238 gets underway once more from Bournemouth Central on 12 June 1965. (Strathwood Library Collection)

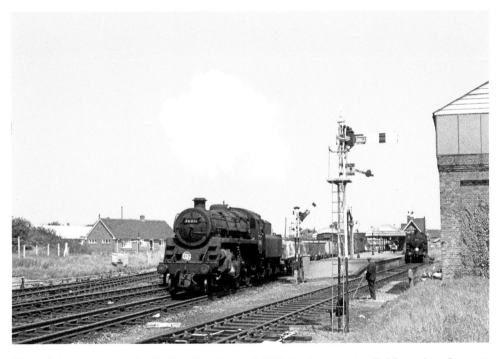

The yard shunter stands ready with his pole as Standard 4MT 76011 has been signalled forward on 1 June 1966 at Wareham while an Ivatt 2MT waits in the bay. (Strathwood Library Collection)

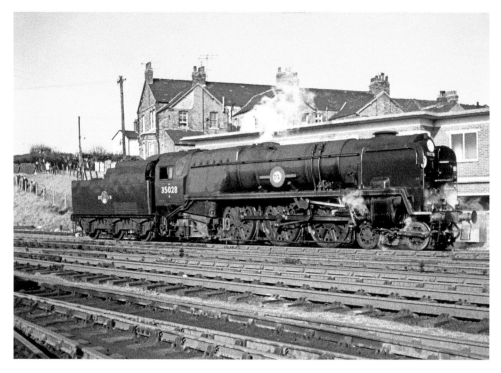

Merchant Navy 35028 *Clan Line* appears to be well burnished and in fine fettle as the big Pacific backs away from our position at Weymouth on 27 February 1966. (Strathwood Library Collection)

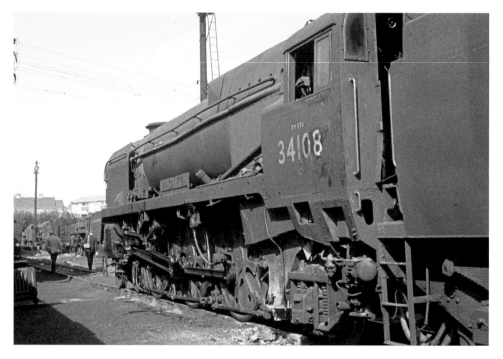

The fire has been dropped on West Country 34108 *Wincanton* during this 1965 visit to the shed for these two enthusiasts at Weymouth, as they make their way around. (Win Wall/Strathwood Library Collection)

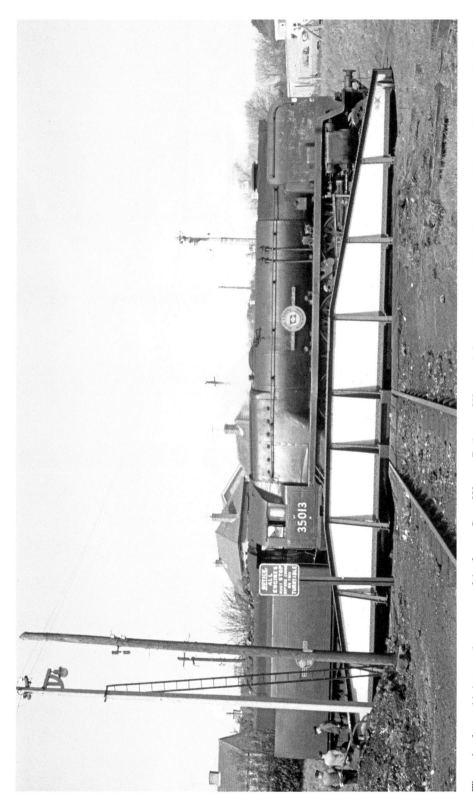

The style of turntable betrays the presence of the former Great Western Railway at Weymouth during the same visit in 1965 as we see Merchant Navy 35013 *Blue Funnel* being turned. (Win Wall/Strathwood Library Collection)

Southern Specials

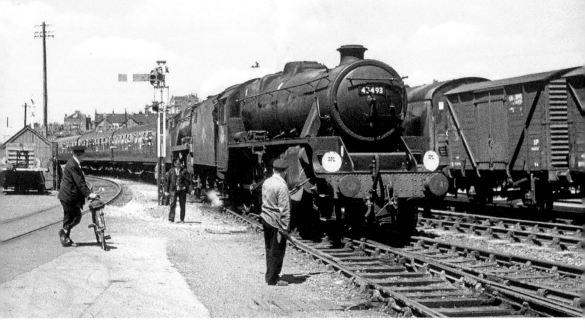

The flag man beckons on the crews of Black Five 45493 and West Country 34100 *Appledore* at Weymouth Quay with the infamous LCGB Green Arrow Rail Tour on 3 July 1966. (Strathwood Library Collection)

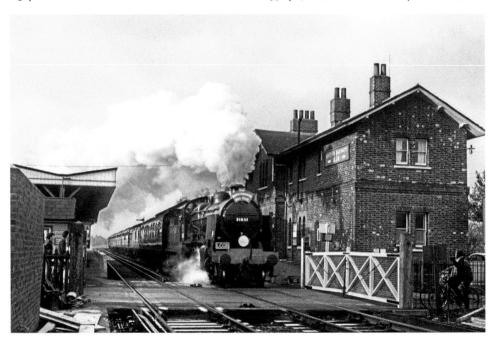

The signalman at Ash has closed his gates well in advance on a frosty 3 January 1965 to ensure he does not check the progress of Maunsell N Class 31831, one of four of the designer's locomotives to be used on the LCGB Maunsell Commemorative Rail Tour. (Strathwood Library Collection)

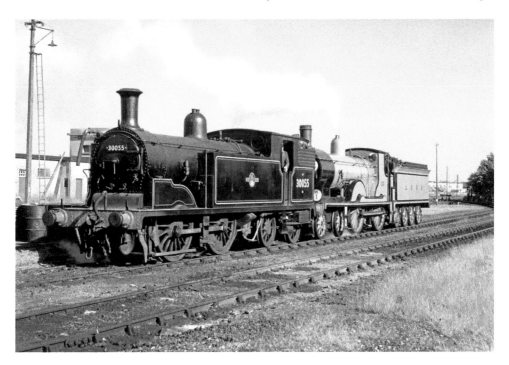

A Drummond pairing of M7 30055 and the preserved 4-4-0 Class T9 120 at Eastbourne on 24 June 1962 will take the LCGB organised Sussex Coast Limited forward on the next leg to Rotherfield. (David Cobbe/Strathwood Library Collection)

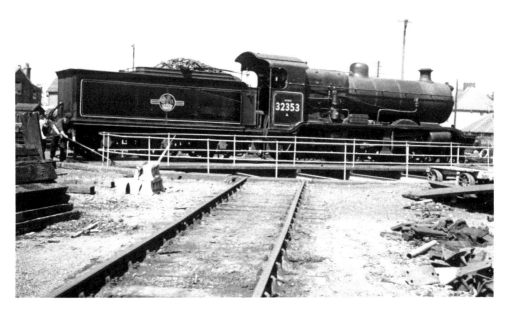

Taken on the same railtour at Bognor Regis, where Class K 2-6-0 32353 was turned before going onwards to Haywards Heath after lunch. (Late Vincent Heckford/Strathwood Library Collection)

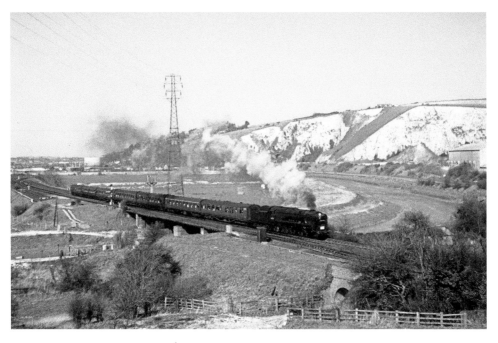

A run across the chalk downs at Southerham Junction near Lewes for West Country 34108 *Wincanton* on 19 March 1967 as part of the SCTS Southern Rambler tour, advertised as the last steam train to Brighton and Eastbourne. (Peter Simmonds)

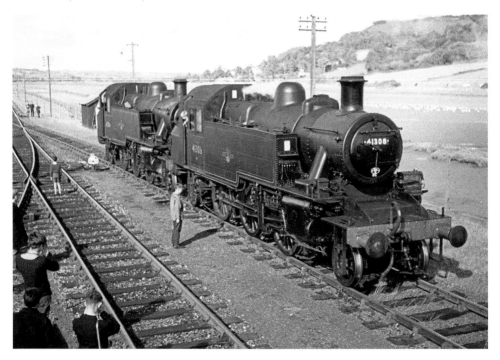

You can almost hear the camera carrying enthusiasts shouting at the two lads in this view of Ivatt 2MTs 41308 and 41206 at Seaton as part of the same SCTS Farewell to Steam tour that utilised 92220 *Evening Star*, which we saw run earlier on 20 September 1964. (Winston Cole)

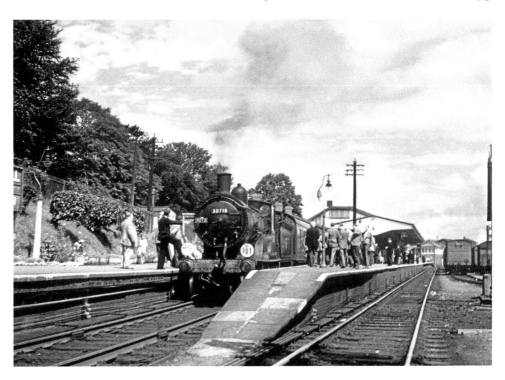

A stop for ten minutes was made at Yeovil Pen Mill on 14 August 1960 when the RCTS ran their Greyhound Rail Tour, which had Drummond T9 30718 at the helm for several legs that day. (Frank Hornby)

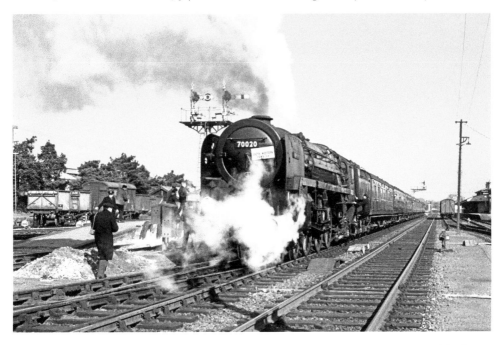

A member of station staff is waving cameramen back onto their train at Andover Junction on 8 March 1964 with Britannia 70020 *Mercury* blowing off from the safety valves and the footplate crew climbing back aboard on the SCTS South Western Rambler. (Strathwood Library Collection)

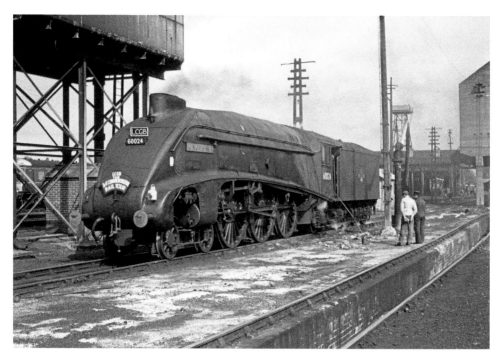

The fire is being cleaned during the two-hour layover at Exeter St Davids, allowing Gresley A4 60024 *Kingfisher* to go on shed at Exmouth Junction on 27 March 1966 whilst working The A4 Commemorative Rail Tour arranged by the LCGB. (Strathwood Library Collection)

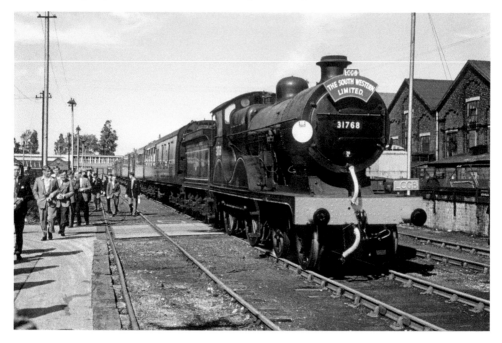

On 18 September 1960 L Class 4-4-0 31768 handled the stretch from Ascot into Eastleigh Works as part of the LCGB's The South Western Limited tour, which allowed the participants one hour to get around the works before the next leg. (Strathwood Library Collection)

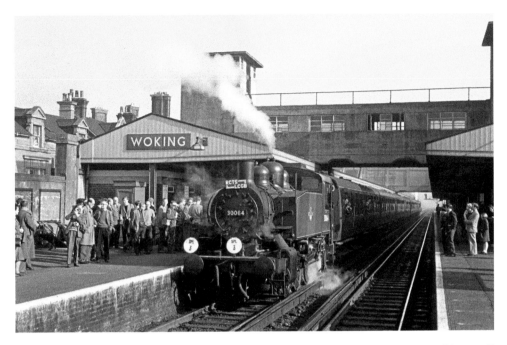

The RCTS and LCGB have combined to run The Midhurst Belle Rail Tour which will use USA 0-6-0T 30064 from Woking to Stammerham Junction on the glorious morning of 18 October 1964. (Strathwood Library Collection)

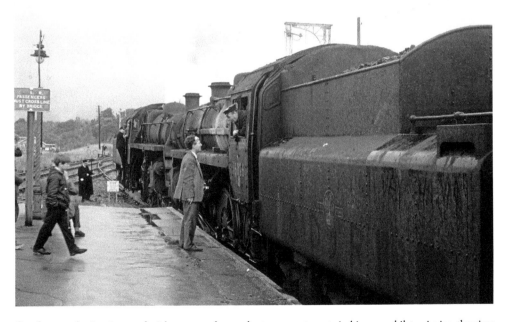

One keen enthusiast is armed with motorcycle goggles to prevent smuts in his eyes whilst enjoying the view from the carriage windows during his railtours, such as the LCGB Dorset & Hants Rail Tour on 16 October 1966, which had the strange combination of Standards 76026 and 77014 running smokebox to smokebox at Hamworthy Junction. (Strathwood Library Collection)